A Passion for People

The Story of
Mary Mahoney
and Her Old French House Restaurant

Edward J. Lepoma

QUAIL RIDGE PRESS
Brandon, Mississippi

DEDICATION

To my mother, Rose, and my father, Tony Lepoma,
who have always supported me
no matter which path I chose.
Thank you for your love and encouragement.
I love you both very much.

Cover photo of restaurant courtyard by Ken Murphy
South Beach Studios (228) 467-5999

Lepoma, Edward J.
 A passion for people: the story of Mary Mahoney and her Old
French House Restaurant / Edward J. Lepoma.
 p. cm.
 ISBN 0-937552-94-1
 1. Mahoney, Mary, 1924-1985. 2. Restaurateurs--Mississippi--
Biloxi--Biography. 3. Old French House Restaurant. I. Mahoney,
Mary, 1924-1985. I. Old French House Restaurant. III. Title.
TX910.5.M32L47 1998
647.95'092--dc21
[B] 98-28077
 CIP

QUAIL RIDGE PRESS
P. O. Box 123 • Brandon, MS 39043
1-800-343-1583
E-Mail: Info@QuailRidge.com / Website: www.QuailRidge.com

CONTENTS

ACKNOWLEDGMENTS

WHEN I BEGAN researching the life and times of Mary Mahoney, I asked almost everyone I interviewed to try to remember the first time they met this extraordinary woman.

Later, I asked the same question of myself.

I was introduced to Mary by my good friend and mentor, the late A. J. Swansine. A. J. was known around town as "Mr. J. C. Penney" because of his long association with the clothing store, situated in downtown Biloxi on Howard Avenue, then at Edgewater Mall.

Like Mary, A. J. was born and raised in Biloxi, and he was proud of it. He and Mary shared a love for their city and the Mississippi Gulf Coast. They traveled all over the world, but were quick to tell you there was no place like home.

I worked with A. J. at J. C. Penney during holidays and summers of my high school and college days. He brought me to Mary Mahoney's Old French House Restaurant sometime in May 1964. The restaurant had been open only a few weeks, and A. J. said it would be a wonderful place to celebrate my graduation from the University of Southern Mississippi in Hattiesburg.

Mary, dressed in a flowing gown, greeted us at the door the instant we arrived. A. J. introduced me to her. I was surprised to learn she knew my father, Tony Lepoma, and his brother, Joe. Both men were Coca-Cola salesmen and from time to time, one or the other had delivered Cokes to her Uncle Dominick's store on Howard Avenue and her father's store at Bayview and Main. Mary directed us to a table in the restaurant's intimate Slave Quarter section and ordered our drinks. I had my first martini ever—Tanqueray on the rocks with double olives. Mary had one with us.

I told her I was getting my degree in journalism, and that I already had a job offer as a cub reporter on a daily newspaper starting up in Pascagoula, Mississippi. She said she thought that was wonderful and remarked prophetically, "Maybe you'll write about this place one day." Then she was off to table-hop with the other customers coming in for the evening.

I continued to pursue my career as a reporter and by the mid 1960s

I was covering stories for the *Mobile Register* in Alabama. At the time of the now-famous Selma Civil Rights March, I was in Montgomery working for United Press International. In 1968, I moved to New Orleans to cover politics and city hall for the afternoon edition *States-Item* newspaper. Mary Mahoney enjoyed a friendship with Tommy Griffin, who wrote the newspaper's most popular social column, "Lagniappe." Tommy later told me that Mary called him one day and asked him to "take care" of me.

Of course, I came back home to Biloxi from time to time, no matter where I lived and worked. I always visited Mary's restaurant and she and I would sit and talk for hours about what was going on in each of our careers. She loved politics and was eager to hear about my encounters with Governors George and Lurleen Wallace. In 1970, when a young and progressive mayor named Moon Landrieu took over the reins of city government in New Orleans, Mary wanted to know everything about him and his vision for the city. "Tell me some of the things you can't print, too," she'd tease.

Invariably, when I'd visit the restaurant, she delighted in showing me the latest clippings written up about the place in various regional and national magazines. Mary was proud of the success of her restaurant and the notoriety it had rightfully achieved. "All the articles are wonderful, but I know you writers have space restraints," Mary said. "I hope one day I'll get around to telling the whole story myself."

Mary never got the chance to put her thoughts on paper, but I happened to be in the restaurant the evening of St. Patrick's Day in March 1995. Her son Bobby approached me at the bar. "I'd like you to write my mama's story," he said. Naturally, I told him I'd be honored.

My thanks to Bobby, Bob, Sr., Mary's daughter Eileen, Mary's brother Andrew, and her sister Annie Clark for entrusting me with this project.

Thanks, too, to all the friends of Mary who consented to be interviewed.

Twelve years after her untimely death, Mary Mahoney lives on in our memories. That is undoubtedly the greatest tribute to anyone's life.

The story that follows was a labor of love.

PREFACE

"There is nothing which has yet been contrived by man by which so much happiness is produced as by a good tavern or pub."

—SAMUEL JOHNSON (1709-1784)

No one knows how much thought or research went into finding those immortal words, but Mary Mahoney used that inspiration to build what has become the premiere restaurant of the Mississippi Gulf Coast.

This daughter of an immigrant fisherman set out with little money and sheer determination to create an elegant but informal atmosphere where dining was again elevated to an art. Along the way, she nurtured her family and maintained lifelong friendships. Mary was loved by everyone who had the good fortune to meet her.

More than thirty years after its founding, the fame of Mary Mahoney's Old French House Restaurant has exceeded even Mary's wildest dreams. The establishment has hosted famous statesmen and businessmen. It has become a favorite of actors and actresses, television stars, recording artists, musicians, athletes, and—of course—writers.

The Old French House remains a haven for locals who come to escape the tensions of everyday life, and has become a refuge for tourists looking to recapture the ambience of the Old South.

Guests from all fifty states have dined there, and others have visited from Central and South America, Europe, and Asia. Mary proudly fed presidents from the restaurant's menu on the White House lawn.

The reputation of Mary Mahoney's Old French House Restaurant extends into the corridors of Congress and the capitals of Europe. The restaurant continues today to garner top honors from national gourmet magazines. Its success is testimony to Mary Mahoney's vision and hard work.

A Passion for People

The Story of

Mary Mahoney

and Her Old French House Restaurant

CHAPTER 1

The Early Years

Mary Mahoney was born Mary Antonia Cvitanovich on July 1, 1924. World War I was over and the nation was at peace. It was an exciting time to come into the world. Prohibition was the law of the land during "The Roaring Twenties." But the Mississippi Gulf Coast was awash in bootleg gin, and from Mobile to New Orleans the partying was non-stop.

In 1924, Mary's hometown of Biloxi, Mississippi, like its neighbors along the Gulf Coast, was enjoying a time of great prosperity and growth. Biloxi had emerged as "The Shrimp Capital of the World" and the city's cash registers were brimming with shrimp nickels. The factories lining East Beach and Back Bay coined their own money to pay the women and children who processed the shrimp and canned them for shipping across the country. Liquid left on the unwashed hands of shrimp pickers turned the coins green and the term "shrimp nickel" was born.

Just three days after Mary's birth, on July 4, 1924, Biloxi's newest and finest hotel, the Buena Vista, opened amid much fanfare. Partygoers came by rail from as far away as Chicago to attend the grand opening. The $400,000 Spanish mission-style hotel boasted 100 rooms, each with a private bath, and the most spacious lobby of any hotel on the Mississippi coast. The Buena Vista joined others already situated along front beach: the Hotel Belmar, the White House, and the Hotel Biloxi. The Buena Vista, and in particular the hotel's Marine Room Lounge, would become one of Mary's favorite late-night haunts.

Mary Mahoney was born under the sign of Cancer, symbolized in the Zodiac by the Crab. Some say Cancer is the most sensitive sign in the Zodiac. Mary's friend Eddy Alley, who shared her love for "reading the stars," says she exhibited the true characteristics of her astrological birth sign. "Like her symbol, the crab, those born under Cancer hide their soft interior beneath a tough exterior that is hard to penetrate. Only those that Cancers really trust get to see what lies beneath that shell," he said. Those born under the sign are devoted to home and family, placing their loved ones above everything else in life. They are extremely loyal, always ready to defend a friend. Cancers are patriotic to the extreme, and their love of "family" reaches out to the community, the region, and the country.

Mary never forgot her birth family or her humble beginnings. She loved to tell the story of how her father arrived in the United States, a boy of sixteen who couldn't speak a word of English. "He got off the boat at Ellis Island in New York in 1906, the day after the great

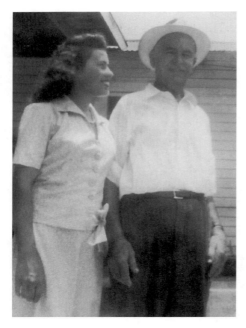

Mary and her beloved father, Tony.

San Francisco earthquake," Mary recalled in a speech she taped before the Biloxi Friends of the Library. "He had a name tag on him and instructions to send him to relatives in Louisiana—they would get him a job." Right off the boat, Tony Cvitanovich was greeted by workers for the American Red Cross who were collecting money for the quake victims. He held tight to the few coins he had in his pants pocket. "He learned right away that this was not the land of opportunity where the streets were paved with gold," Mary recalled. "He knew he was going to have to work for everything he got."

Tony Cvitanovich was born in Ingrene, Yugoslavia, between Dubrovnik and Split, on the beautiful Adriatic Coast. He was in the vanguard of young men who fled Europe before the onset of World War I to avoid conscription in the Austrian Army. Mary's mother, Mary Elizabeth Trojanovich, was born in Tresteno, sixty miles east of Ingrene. Both towns were part of the conquered Province of Dalmatia, which became part of Yugoslavia after the war. Sixteen years would pass before Tony Cvitanovich and Mary Trojanovich would meet in Biloxi and marry.

Tony spent his first two years in Louisiana culling oysters for twenty cents a sack off the reefs of Port Sulphur and Venice. During this time he stayed with relatives, who provided food and shelter. Tony saved his money, and in 1908 sent for his brother Dominick. Together, they worked the reefs off Buras and Empire. They rented a room in a New Orleans boarding house run by a sea captain. Sometimes, they would sell the oysters off the wagon to the fancy restaurants in the city for a better price then they would get selling to locals.

In 1912, with money they'd both saved, Tony and Dominick sent for another brother, Tom. Like Tony, Tom was sixteen years old when he came to America. Tony and Dominick wanted Tom to work in the restaurants in New Orleans at night and go to school in the day, but Tom decided to join his brothers in the backbreaking oystering business.

Around 1916, Tony and Dominick pooled their money and purchased a bar. The Green Turtle Saloon was located at the corner of Annette Street and Claiborne Avenue in uptown New Orleans. Mary's sister, Annie Clark, loves to repeat the story her father told her: "The

barroom was a pretty popular place, and would sometimes stay open all night. It was Daddy's turn to stay up and watch the bar. He fell asleep behind the counter, and someone came in and emptied the cash register. After that, he didn't want any part of the bar business. They sold out."

The Cvitanovich brothers returned to oystering. In 1918 when the United States was preparing to enter World War I, Tony received an offer from the federal government and went to New Jersey to work in an ammunition plant. In his absence Dominick and Tom ran the oystering operation. To this day, relatives don't know exactly what work Tony was hired to do except that it was research with oyster shells and it paid good money. But, Tony didn't like the cold North, and after only three months, he came back to Louisiana. By the time he returned, Dominick had taken a bride. The brothers felt they were getting a little old for oystering and were looking to change careers. They again pooled their monies and bought two shrimp boats. They began trawling off the coast of Louisiana, but learned that Biloxi presented a better opportunity for the commercial shrimper. The Cvitanovich brothers arrived in Biloxi on their shrimp boat, "The Young Bride," the day before Christmas 1920. They rented a house on Oak Street between Howard Avenue and the beach. In Biloxi, they felt right at home. The city, particularly the Point Cadet area, was home to hordes of immigrant Yugoslavs who came to work in the booming shrimp factories.

MARY TROJANOVICH arrived in Biloxi from her native Tresteno, Yugoslavia in 1922. Her father, a wealthy businessman, lost his fortune investing in Austro-Hungary bonds during the buildup to World War I. Mary had no dowry to offer a suitor, and her father convinced her she should go to America to find a husband and a new life. She was sent to Biloxi to stay with an elderly aunt, Marion Pillosata, whose husband was a groundskeeper for the Woods Estate, which was near Biloxi High School on Howard Avenue. Mary lived with her aunt and uncle in an old wooden house in back of the property on Bellman Street. "They treated my mother like a paid servant," Annie said her mother confessed in later years. "She'd do all the housework and all the sewing. Then they would send her off to the shrimp factory to work the rest of the day."

Mary's parents, Tony and Mary Cvitanovich are shown front and center, with Mary and Bob Mahoney and Mary's brother Andrew to the left in this family portrait.

Mary was walking to the factory one day when Tony Cvitanovich first saw her. She was saying her rosary, fingering the beads in her hands as she walked, and Tony thought to himself, "I have to meet this Saint." Introductions were made, and the two started courting under the watchful eye of Aunt Marion. Annie said her mother told her Tony would come and call for her in his Model T. Mary would ride in the back seat while Aunt Marion sat in the front with Tony.

Despite the hardships, romance blossomed, and Tony and Mary were married in a solemn Catholic mass at the Church of the Nativity on June 18, 1923. After a short honeymoon in New Orleans, the newlyweds settled into a new house Tony had built on East Howard Avenue near Crawford, not far from where his brother Dominick lived.

From left, Mary, brother Andrew, and sister Annie pose for a formal portrait.

Mary was the first born, then Annie, then Andrew. Annie recalls sister Mary as "always bigger than life. . . a rambunctious, overactive child Mary was two and a half years older than me. Andrew and I were only eleven months apart, so we were a lot closer, but Mary would let us tag along with her and her friends sometime," Annie said.

Annie remembers that, even at an early age, Mary saw beauty in things around her. "One of my fondest memories goes back to the day we were riding in the back of my father's truck. We were standing up in the back of the cab like you couldn't do today. We were riding past the Coast Guard Station they were just building on Point Cadet, and a beautiful white horse ran past us. Mary hugged me and said, 'Look at that! I will never, ever forget this!' I hugged her back, and said, 'I won't either.' I felt a little bit closer to her that day."

Annie said Mary had her father's personality and zest for life. "They were both outgoing—people-oriented—and loved to be in the center of things," Annie declares, "not because they wanted to be in control, but out of sheer joy."

Mary entered grade school at St. Michael's on the Point. There she studied under the watchful eye of Father Herbert Mullin who, everyone agrees, became the most influential person in her adoles-

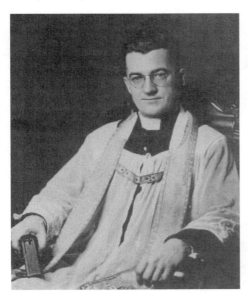

The Rev. Herbert Mullin, pastor of St. Michael's Catholic Church, became Mary's protege and confidant.

cent and adult life. Annie remembers that even in grade school, Mary relished being in the spotlight. "St. Michael's had an annual festival in the Spring, and you got to be Queen by selling the most tickets. I remember Daddy and Mary out there selling tickets like crazy. Mary got to be Queen, and she loved it."

Growing up, Mary and Annie shared a love of poetry, as did most girls in the 1930s and 40s. "We would memorize whole stanzas," Annie recalls, "Mary would especially love Poe, Elizabeth Barrett Browning, and Longfellow. I can still hear her in my mind reciting, 'How do I love thee. Let me count the ways.'"

The sisters also cultivated an early love for politics. Annie said she and Mary stayed up all night in 1936 listening to the results of the Presidential election on the radio. They made a chart of election returns state by state, and finally went to sleep about 6 a.m., only after they knew Franklin Roosevelt had won.

WHAT KIND OF STUDENT was Mary? In these days of testing, we might conclude that Mary had a short attention span. "She grasped most subjects when she put her mind to it," Annie said, "But she was an atrocious speller." Father Mullin took Mary and some of the other girls under his wing. Most of the time, he'd end up doing their homework for them.

Father Mullin's brother, Dr. Peter Mullin, who now lives in Biloxi, said his brother began the practice of giving Mary and "his girls" a word each day to learn to spell and use the following day in a sentence. One day the word selected was "pecunious," which meant "poverty stricken." The next day when Father Mullin asked Mary to use it in a sentence, she said, "I didn't do my homework last night, and I feel so pecunious about it." Mary had thought the word described somebody "grief stricken."

Dr. Mullin said the nuns who taught Mary and some of the other girls under Father Mullin's charge couldn't figure out what was going on. Mary always had her homework done correctly, but she barely passed the tests, and sometime she would fail. That was because Father Mullin would sometimes tire of helping the girls with their homework, so he'd complete the lessons for them.

Mary eventually progressed to Sacred Heart All Girls Academy.

The girls of Sacred Heart Academy graduated jointly with the boys attending Notre Dame High School.

Annie remembers the night she stole the show at a high school performance. The play was "The Rivals—Mrs. Malaprop," an eighteenth-century comedy, in which Mary played the lead, Mrs. Malaprop. According to Annie, Mary brought down the house. "She was so funny and a natural on stage."

Mary also had a good singing voice and confided to Annie one day that she wanted to be an opera star. Growing up, both sisters had cultivated a love for opera. Mary was discouraged, however, when Father Mullin told her she would have to learn Italian, German, and French and study for many years. Father Mullin may have helped close the door on Mary's dream of becoming an opera diva, but the Oxford-educated priest and mentor opened up many new and won-

derful avenues to Mary. He introduced her to the New York Times and its wonderful magazine section, chocked full of the latest fashions, news about Broadway shows and the hottest Hollywood gossip. Mary quickly developed her own fashion style, and in interviews many years later would confess her secret desire to be a dress designer.

During the sisters' teenage years, Annie made all of Mary's clothes. Mary would give Annie a picture she had cut out of the Times and ask Annie to make her a dress just like it on her mama's treadle sewing machine. "Even at an early age, Mary had a flair for fashion," Annie remembers. "Once she decided on the outfit, she'd go out hunting for the right accessories. I'm sure, if she had put her mind to it, she could have been a great fashion designer." In appreciation for Annie's hard work, Mary decided to buy her sister an electric sewing machine. She went downtown and bought the latest Sears had to offer. This was at a time when you could put a dollar down on something and pay a dollar a week until it was yours.

Cupid Strikes

*M*ary managed to graduate from Sacred Heart, and the family breathed a collective sigh of relief. She had never been away from home for any extended length of time, but she talked her daddy into letting her attend Perkinston Junior College in Wiggins, about fifty miles north of Biloxi. At Perkinston, Mary studied business courses, but after about a year, she decided to come back home.

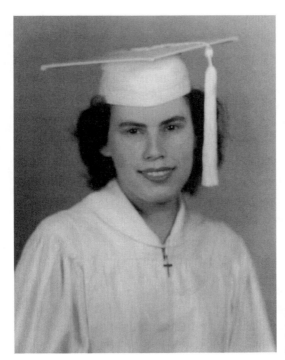

Mary's high school graduation picture.

Back in Biloxi, Mary made the rounds looking for work. She landed a clerical job at Keesler Air Force Base. Working at the growing base was considered a good career opportunity at the time, and offered her the chance to meet men coming into town from all over the country. It was on this job that Mary met Jan Schwarz, who would become a lifelong friend and confidant.

World War II was on, and many Biloxi boys were getting drafted or joining the Armed Forces and being shipped out on the big, noisy trains that pulled into the Louisville and Nashville Station on Railroad Street. Men who had selected the Air Force arrived by the hordes in Biloxi for basic or advanced training at Keesler. During the War, Annie remembers Mary would con rations off everyone she could because she had to have this or that pair of shoes. Then the two of them would bake cookies, put them in the shoe boxes, and go to the train depot and give them to the boys going off to war.

Robert Mahoney was one of those Yankee airmen who came to Keesler in the summer of 1945. Bob was born and raised in Williamsport, Pennsylvania, one of six children in an Irish-American family. His father Charles was a fireman, killed in the line of duty when Bob was three. His mother Elizabeth was left alone to raise the children.

Bob joined the Air Force in 1944, and by the time he came to Keesler, he was already a veteran of thirty-five combat missions throughout Europe. He was a flight engineer and held the rank of staff sergeant. Bob spoke with a northern accent. Having heard the stories about local boys beating up on airmen who went downtown to flirt with the local girls, he stayed close to base when he first arrived in Biloxi. Bob didn't know anybody in town and he didn't drink, so the bars that lined downtown and front beach offered no invitation. But he was lonesome for company, and ventured out one afternoon when *The Daily Herald* newspaper reported that St. Michael's Catholic Church was sponsoring a Sunday afternoon dance at the USO Club on East Beach. That's when Cupid struck!

Bob was sitting in the main ballroom eating a sandwich when Mary walked by. "The world lit up!" he remembers. The Yankee from Pennsylvania was introduced to Mary and to this day doesn't remember exactly what he said. But that night he set his sights on getting a date

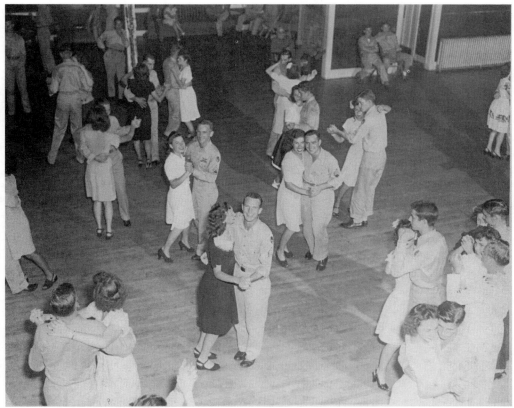

Mary met Bob Mahoney at a Sunday afternoon dance at the U.S.O. Club sponsored by St. Michael's Church. Here, they are shown dancing (center right).

with "the girl of his dreams."

As fate would have it, Mary, then about twenty years old, was working at Keesler's Base Locator's Section, the Air Force term for post office. Bob was crew chief for a flight squadron hangared right next door, and he "popped in" every day to chat with Mary. Finally he worked up the nerve to ask her out on a date. Mary had never dated a Yankee before or any outsider whom her family knew nothing about. But, Bob persisted, and she accepted.

Mary felt nervous about introducing her date to her parents. Her mother spoke little English even though she had been in the country now twenty-two years. And, Mary was afraid her parents might reject this "outsider" outright, as they had always hoped she would pick a suitor from among the eligible boys in the Slovanian community. Bob had already won Mary's heart, though, and he found a way

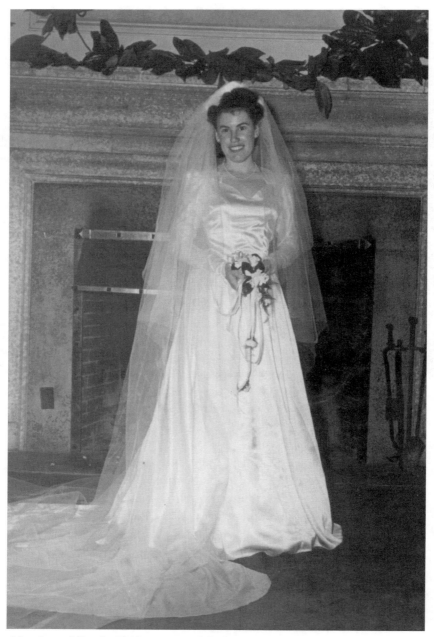

Mary's wedding in 1945 was one of the biggest events of the year in Biloxi, with over 300 invited guests.

to get her parents to bless the union. He told them his brother, Charles, was a Catholic priest. That won them over. Bob jokes that throughout the marriage, Mary's folks sided with him whenever there was a conflict. "After all, the brother of a Catholic priest couldn't possibly do anything wrong," he says, laughing.

The courtship lasted about eight months, and a wedding date was set. The invitations were sent out. Mary Antonia Cvitanovich, the firstborn daughter of Tony and Mary Cvitanovich, was to marry Robert F. Mahoney in a Nuptial High Mass at St. Michael's Church on the Point at 10:30 a.m., November 25, the Sunday after Thanksgiving, 1945.

By the time Mary was betrothed, her father had become a very successful businessman, well-known and respected in the community. He owned a fleet of twelve shrimp boats and a seafood factory at the foot of Main Street and Bayview Avenue. The Sanitary Fish and Oyster Co. later became Southern Seafoods. Tony's shrimp were being sent across the country under the "Commander" label, named for one of his boats.

Mary's wedding was one of the biggest events of the year in Biloxi. At least 300 guest were invited, including Mary's relatives from Buras and New Orleans, and Bob's family from Pennsylvania. The double-ring ceremony was performed by Bob's brother, the Rev. Charles Mahoney, CSC, who came down from Philadelphia for the occasion. The Nuptial Mass was celebrated proudly by a beaming Father Mullin, who now was pastor of St. Michael's.

Mary had gone to New York to select her wedding dress and trousseau. Everything had to be perfect and at the height of fashion. *The Daily Herald* gave this description of her wedding:

> "The bride was lovely in a gown of traditional white satin, styled with a sweetheart neckline and full skirt over a hoop ending in a long train. Her full-length tulle veil fell from a white satin tiara into which was also gathered the shortface veil which she wore as she approached the altar on the arm of her father, who gave her in marriage.
>
> "At the throat, Miss Cvitanovich wore a single strand of pearls, her wedding gift from the bridegroom. She carried a white satin-covered prayerbook to which white satin streamers interlaced with white gardenias were attached."

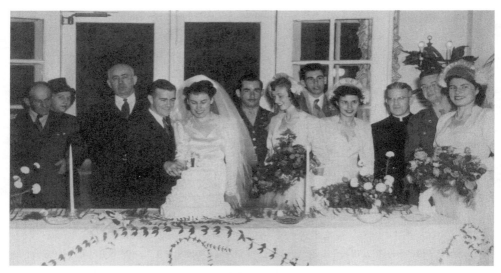

*The Mahoneys cut the cake at an elaborate reception at the Biloxi Hotel
following their wedding.*

Mary's sister, Annie, was Maid of Honor. Other bridesmaids included Bob's sister, Reda Mahoney of Williamsport, Pennsylvania; Miss Elizabeth Johannsen of Biloxi; and Miss Gloria Cvitanovich, Mary's cousin from Buras, Louisiana. Capt. Anthony Cvitanovich, USAAF, cousin of the bride, was Best Man. Ushers were Capt. Ralph Finkler of Lasalle, Illinois; Floyd Blackwell of California; and Andrew Cvitanovich, brother of the bride.

Barbara Lyons, Dominick's daughter and Mary's first cousin, remembers how Mary's daddy helped ease the tension of the solemn wedding ceremony with his humor: "Uncle Tony lifted Mary's veil and kissed her. Then he put her veil back down, and as he walked away, he made a little pushing sign with both hands, as if to say, 'Thank god! I finally got her married off.'"

Following the ceremony, the wedding party went to the Hotel Biloxi, where breakfast was served to the immediate families and out-of-town guests. That evening, a reception was held in the lounge of the hotel where hundreds of friends gathered to congratulate the newlyweds and wish them well for the future.

Mary's flair for style was duly noted in *The Daily Herald* article, which described her honeymoon trousseau:

"Mrs. Mahoney was attired in a black broadcloth and velvet suit with black and white accessories, and she carried a black ostrich plume muff."

Mary and Bob took the L&N train to New Orleans for a brief honeymoon. They returned to Biloxi for a few days before going on to Williamsport to spend the holiday season with Bob's family. When they returned to Biloxi, they settled down in a little two-room bungalow on Howard Avenue behind her Uncle Dominick's grocery. Bob decided to leave the Air Force. He went to work at the seafood factory for his father-in-law where he helped pack and freeze shrimp and delivered them to the train depot for shipment.

Shortly after they settled into their married life, it was discovered that Mary was with child. Bob recalls Mary praying daily that the baby wouldn't arrive early. "Those old ladies in the Point would mark their calendars, and the gossip would start when a baby came too soon after a marriage," he said. Robert F. Mahoney, Jr., whom Mary would later call "my first flower," was born August 11, 1946, a full

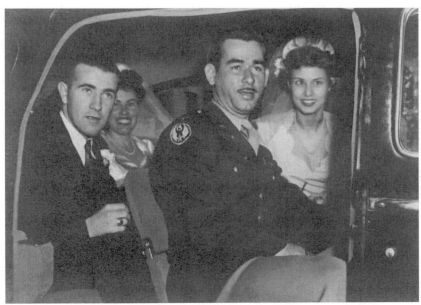

Mary and Bob took the L&N Train from Biloxi to honeymoon in New Orleans.

nine months after the wedding, so the tongues did not wag.

Bobby was just a little over a year old when the big hurricane struck Biloxi head-on September 17, 1947. It was one of the most destructive hurricanes ever to hit the Mississippi Coast. Mary's father lost only one boat in the storm, and the seafood factory withstood the winds and tide without sustaining major damage. However, Tony suffered a mild stroke shortly after the hurricane, and subsequently lost interest in the business. Son Andrew dropped out of Notre Dame High School to step in and help his brother-in-law, Bob run the business. Tony later decided to sell the factory and most of the fleet. He kept a boat for himself and one for Andrew. Like his brother, Dominick, he opened a neighborhood grocery store on the bay catering primarily to the fishing fleet. He and Mary moved into the cottage behind the store, and Mary and Bob took over the family home on Howard Avenue.

Mary went to work side by side with her mother in the store every day. It opened early in the morning to supply shrimpers going out for the day's catch and it didn't close until late each night. Annie remembers, "They would fill the orders into a wheelbarrow, and Mary would roll the wagon down the wharf to the boats. The shrimp boats would sometimes dock three abreast, and Mary would go from boat to boat putting the provisions in the cabin and talking to everyone along the way. She knew everybody by name, and everybody knew her.

Elda (Trahan) McGill was growing up on Main Street when Mary worked at the grocery store. She remembers Mary barreling down Main in the family station wagon, probably on her way to get supplies from wholesalers. "We called her 'Old Iron Foot,'" McGill recalled. "If I saw her coming, and I was headed for school at St. John's, I wouldn't get off my porch until she passed by."

The young Mahoney family continued to help in the family grocery, and Mary learned she was pregnant again. She gave birth to a baby girl and although she was brought to full term, the child died a day or so afterwards.

However, fate would soon intervene and set the young couple on a whole new career path.

Otis Bosarge heard that Bob could pitch a softball pretty well. He

convinced Bob to pitch for Desporte Bakery's team. Then Devoy Colbert, who owned the Beachwater Club, stole Bob away to pitch for his team. Devoy also hired Bob to come work for him as a night auditor at the club. Bob later held similar positions at the White House Hotel and the Buena Vista Hotels.

In 1951, Arkansas businessman A. B. Minor bought the Tivoli Hotel on East Beach. He owned an outdoor sign company in Arkansas and traveled a great deal. He wanted a manager to live on the hotel premises, and he recruited Bob for the job. At the same time, he also offered Bob a verbal lease on the hotel lounge. If Bob chose to operate it and it succeeded, most of the profits would be his to keep. If it failed, the loss was his, too. So Mary, Bob, and Bobby moved into the hotel—rent free.

CHAPTER 3

The Bar Venture Begins

*B*ob contacted the beer and liquor distributors, and got the bar ready for opening. He hired a couple of barmaids—but Mary wasn't considered for that job. Initially, business was slow. The bar's clientele consisted of traveling salesmen captive at the hotel for a few nights, and the few individuals who lived there for months at a time. But most bars depend on locals to at least cover expenses, like utilities and rent. Bob said the barmaids mixed good drinks, but spent most of their time reading magazines, paying little attention to the customers. Mary offered to run the bar, admitting she didn't have much experience mixing drinks. Bob took her up on it and laid off the barmaids, cutting his overhead.

It so happened that one of the regulars—Irby McGee—came in for a drink the afternoon Mary took over the place. McGee, an accountant with Kennedy Marine, lived at the hotel. He sat down and asked Mary to fix him a Manhattan. When Mary asked him how to make it, McGee laughed, but he talked her through it. Mary looked anxious when she placed the drink in front of him, rolling her eyes upward, as she did on such occasions to invoke help from the Holy Spirit. After taking a sip, McGee looked up at Mary and smiled broadly, smacking his lips. He told Mary it was "The best damned Manhattan he had ever tasted." Mary beamed.

"She was a natural behind the bar," Bob recalls. After that first day, Bob told her the bar was hers, to run as she pleased. Mary was thrilled but a little panic-stricken. She had never been in control of anything in her whole life, though she wasn't scared of hard work

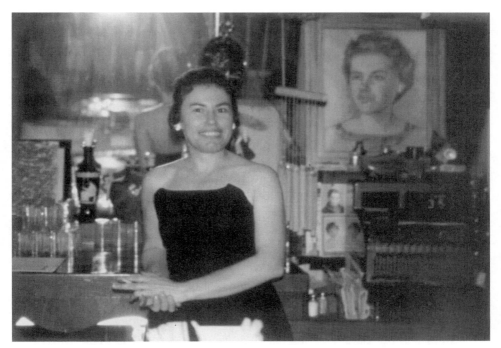

Mary was a natural behind a bar and soon began to attract locals, as well as tourists to her lounge in the Tivoli Hotel.

Mary proudly poses in front of her lounge where her name was emblazened in neon lights.

and long hours. Mary had to find somebody to take care of Bobby, now going on ten, and she had to get out the word that she was now the proud owner and operator of the Tivoli Hotel lounge. A few months after the bar opened Mary became pregnant again, but later miscarried.

Mary and Bob agreed that a man was needed around the place, just in case things got out of hand. Bob suggested they hire Bob Renker, one of his Air Force buddies, to help out around the bar and serve as handyman and bouncer. Renker was good at fixing things and he had a lot of friends at Keesler.

Bob began to broadcast their business. He invited his buddies from Keesler and his ballplaying friends. He spoke with colleagues at other hotels along the beach. It wasn't long before Mary's bar attracted a loyal following. Elmer Williams arrived faithfully each morning when Mary opened up around 10 o'clock. Williams owned DeJean Packing Co. on the beach almost directly across from the hotel. He knew Mary and her parents, and was always considered a friend and supporter. Later, Williams' nephew, Marion, became a regular too, stopping at the bar with his companion, Holmes Love, before they moved off to live in Washington, D.C. "It was just a wonderful, fun place to go. The place was usually packed with all kinds of interesting people,"

Elmer Williams, who owned DeJean Packing Co. on the beach, was an early regular at the bar and one of Mary's chief supporters.

said Marion Williams. "And Mary always had time to talk with everybody, and she made everyone feel so special."

Vernon Pringle took a liking to the little place. Vernon's father owned the local Ford dealership and had sold Mary's father his first Model T and subsequent Fords after that. Vernon, who had gone to school with Mary's sister, Annie, and had just graduated from college. When he began frequenting the bar, he remembers it had about eight or ten stools, and it was always packed. "And Mary would keep the lounge open 'til four in the morning if you wanted to drink and talk."

Hilda Covacevich started coming in for cocktails after work. A legal secretary for a leading law firm in town, Hilda would become one of Mary's most flamboyant regulars and another life-long friend. Hilda and Mary shared a love of the arts, especially opera and Broadway shows. They were both fashion trendsetters, and over the years would become bosom buddies much like the two leading characters in the musical "Mame."

Jerry O'Keefe found Mary's bar to be a place where he could relax and escape the pressure of the everyday world. O'Keefe would later become a state legislator and mayor of Biloxi. He describes Mary's bar as "a hotbed of political intrigue." Over the years, Mary's lounge would be visited by the likes of Sen. John Eastland, Lt. Gov. Bidwell Adams, and countless other national and local politicians. "Anybody who had any ambitions of running for anything would come down and bend Mary's ear," O'Keefe said. "She had an ear to the ground and knew how most folks felt in the town on any subject. And if you didn't have a chance in hell, she'd tell you. But if she believed in you, she'd defend you to the end, and she'd work to get you elected."

O'Keefe was fresh out of law school in New Orleans when he and his bride, Annette, who grew up in nearby Ocean Springs, decided to come back to the coast to live. Mary and Annette became close friends almost immediately and organized the Young Matrons Carnival Club. Annette said the sole purpose of the club was "to put on our annual Carnival ball, then start planning for the next one as soon as it was over."

Jim Balthrope, who knew Mary and her family all his life, liked to

stop in the bar at night with his friend John Blakeney. Said Balthrope, "Mary's was the place to see and the place to be seen after the opera, a carnival ball, or after any special event. It was always a fun place to be, and the people ran the gamut—from the down-and-out artist to the up-and-coming politician or professional."

Eddy Alley liked to stop in later at night, too, after the 10 o'clock news on television. He worked in the clerical field at Keesler, but didn't become acquainted with Mary until she opened the bar. Alley would often meet his friends Ronnie Fountain and Tom Reed at the bar. "I liked it when it wasn't particularly crowded," said Eddy. He and Mary would talk about old movie stars and old movies. "We would talk for hours," he said.

Mary's first cousin Barbara Cvitanovich (later Mrs. Steven Lyons) started coming in with her friend Elda Trahan (later Mrs. Tom McGill). They remember playing darts and listening to the wonderful selection of records Mary had available. "Mary had everything, from pop to opera to Broadway shows, and anything in between," said Trahan. "And she was always adding to her record collection." Barbara and Elda both had their wedding receptions at Mary's lounge.

Keesler's enlisted and hierarchy also made Mary's their special place. Mary was asked regularly to host affairs for Keesler, such as the going away party for the Commander, or the welcoming party for the new general in charge. She hosted birthday parties for friends. She planned special events for couple's anniversaries. And she always staged an elaborate birthday party for herself, usually around the Fourth of July. At one of her birthday parties, Mary was all frocked out in red, white, and blue, and she got the attention of Tommy Griffin, who often visited restaurants and lounges on the Mississippi Coast. Griffin wrote the daily and well-read social "Lagniappe" column for the daily *New Orleans States-Item*. He described Mary as "one hot firecracker all decked out in a red, white and blue majorette outfit."

Years later, son Bobby would put things in perspective. "My mom was practicing marketing when the term wasn't even in vogue," said Bobby. "She would dress in outlandish outfits. One night she might be unveiling a sketch of Puccini or she might be dressed like her favorite character, Little Mary Sunshine, or wearing a kimono. She

Mary dressed as her favorite character, "Little Mary Sunshine."

would stage parties and all kinds of special events to attract people to her lounge. She put in a piano, and it was there for anybody to play."

Bobby remembers Mary would often "trade off talent for beer . . . an artist or painter would come in, and Mother would give them free beer for a portrait of herself or a sketch. And we have numerous paintings in the restaurant today—of Mother in her carnival outfits and in her red dress—and others that Mother got that way . . . They [the artists] wound up with beer bellies, and Mother wound up with some beautiful and rare paintings," Bobby joked.

Bobby credits a customer who frequented the bar and played piano for free beer with discovering his mother's main attribute—her dynamic personality. "One day Mother came in the lounge and this guy was playing the piano, and Mother was kind of depressed. And she sat down beside the guy and says, 'You're so talented. I wish I had your talent. I have no talents at all. I can't dance, I can't sing. I can't paint. I can't do anything.' The piano player turned to Mary astonished. He looked her right in the eye and scolded, 'Mary, you don't know how talented you are. Do you know how many people can go up and down this bar like you do and talk to everybody like you do and make then feel special? That takes talent.'"

Mary as Cho Cho San, from one of her favorite operas, "Madame Butterfly."

Loyal patrons still remember one particular night when Mary hosted a party to commemorate composer Giacomo Puccini's birthday. Mary was always complaining about the bad acoustics in the lounge, so she called local grocers and told them to save her the discarded egg cartons. Weeks before Puccini's party, she went about town collecting them. Standing on a ladder with a staple gun, Mary began tacking open egg cartons to the ceiling. She had heard somewhere that upside-down cartons would absorb the sound, much like the design of the Hollywood Bowl.

As the date drew near, Mary sent out party invitations. On the day of the event, she placed Puccini's framed picture in a place of honor atop the piano and lit candles, and she

ordered only his operas played during the evening. When the guests began to arrive, Mary made her entrance in a stunning geisha outfit, as the lilting sounds of Madame Butterfly wafted through the bar.

She loved the classics as much as she liked politics. Mary was spellbound by John F. Kennedy, the young Catholic senator from Massachusetts, who began his race for the presidency in 1959. In fact, her bar became the ex-officio headquarters for the Kennedy campaign on the Mississippi Coast. Bob remembers, "A customer came in one night from Palm Beach, and he said he lived right next to the Kennedy compound. He said he'd pass on the word that Mary was Kennedy's biggest fan on the Mississippi Coast. I think Mary only half-believed him." That August, Mary received the following telegram from Kennedy: "I understand you have been working for me for president for the last six months. If I'm elected, you will never regret it," the telegram said. A surprised and thrilled Mary showed it to all her patrons, and collected $50 from Vernon Pringle who bet her that Kennedy—a Catholic—would never be elected President of the United States. It was a bet Pringle later said he was happy to pay off.

When Kennedy was inaugurated, the Mahoneys and the O'Keefes took their families to Washington, D.C. for the inauguration. That inauguration day was one of the harshest on record in Washington history, because of the record snowfall. The foursome didn't attend the parade during the day, but walked from their hotel to the inaugural ball that evening. "As we were going into the reception," Bob recalled, "Mary told me she caught the eye of the President, and he shook her hand. She was so thrilled. I don't think she ever forgot that."

While Mary was well on the way to becoming a legend on the Mississippi Coast, Bob received another job offer. Walter Wilkes, publisher of *The Daily Herald* newspaper, saw Bob as a good prospect for the sale of display advertising. Bob accepted the position. He sold advertising by day and helped babysit Bobby at night. Most of the time, Mary's good friend Jerry Stafford, a regular at the bar and a clerk to Commissioner Pete Elder, minded Bobby. The Mahoneys continued to try to have another baby, even while Mary ran the bar. To their delight, she became pregnant about three years after the bar opened, and on August 16, 1956, Eileen was born.

Bob Mahoney is shown standing in the doorway of the lounge, which Mary called "West Berlin" after the new owner turned off electricity and water in order to force her out.

Around 1961, probably at the height of the bar's popularity, the Tivoli Hotel was sold by its Arkansas owner. By this time, the bar was named "Mary Mahoney's" and a neon sign emblazoned over the entrance proudly displayed her name. The new owner considered the lounge part of the deal although the previous owner had verbally turned it over to Bob. The owner had changed the hotel's name to The Tradewinds Hotel. Mary didn't want to leave. This was her love—her life. Madder than a hornet, she called her dear friend former Lt. Gov. Bidwell Adams. Adams told her that possession was nine-tenths of the law and as long as she occupied the lounge and paid her bills, the new owner couldn't throw her out.

Columnist Griffin reported the standoff in his "Lagniappe" column published August 11, 1961:

> "The vivacious Yugoslav has taken to sleeping in her Trade Winds Hotel bar because the new management wants her out," Griffin wrote. Mary told Griffin she was "staging a lie-in."

The feud with the new owner escalated, and he turned off the electricity. According to Bob, friends who lived in the hotel ran extension cords down from their rooms to the bar so Mary could operate the fans and keep the beer coolers running. The standoff continued into September. This time it was noted by Howard Jacobs, who wrote "Remoulade," a similar gossip column for the competing New Or-

leans morning newspaper, *The Times-Picayune.*

In his column on September 5, 1961, Jacobs wrote:

"Irish Mary had a verbal agreement with the old management . . . that they would give her six months notice. The new management said, 'Amscray.' Mary ignored them. Last week, they cut off the lights, air-conditioning and water. She replied by inviting all her customers to bring in their old fashioned fans and candles and she erected a sign: 'Welcome to West Berlin.'" Jacob's column continued: "The management, miffed by militant Mary's bullishness, boarded up the club for a few days. When Mary came downstairs and found the barricades up to West Berlin, she hit the ceiling. She hotfooted it to the sheriff, who convinced the new owner to remove the boards for the sake of sweet reasonableness. Mary, in turn, agreed to hang up her cue come Labor Day."

After what survivors describe as "a helluva closing party" that went well into the wee hours, the bar was closed, and Mary took

Mary kept up her spirits posing for what was called "a helluvu closing party" after vacating her lounge at the Tivoli Hotel.

with her all the paintings she had collected over the years, as well as her memories.

The new owner tried a new bar in the same location. When it closed within three months, Bob and Mary took some solace from that.

Things weren't entirely grim, however. Before the Mahoneys lost the bar, Father Mullin had told them about the Detwiller property on East Beach next to the Biloxi Hospital that was going on the market. The Mahoneys decided to purchase the property, used most of their life savings for the down payment on the home, and moved Mary's folks in with them. The house on the beach also became a "private" bar for loyal customers like Elmer Williams. Williams, Jerry O'Keefe, and others would come to Mary's house every afternoon and sit around, drinking and talking about the "good old days."

Mary had finally established a career for herself and hoped one day to own another bar. After the fateful closing, she took out a quarter-page ad in *The Daily Herald*. It was a sad, but prophetic notice, which read:

> "Mary Mahoney's Lounge, which has operated at the Trade Winds Hotel for more than eight years, is no more. I would like to take this opportunity to thank my many, many friends for their wonderful patronage and especially to those who were so kind to me the last few months. I shall always be grateful." Mary offered special thanks to Tommy Griffin and Howard Jacobs "for their nice words about me," and promised in a P.S. "I shall look forward to seeing you all soon in a new location."

Mary went back to being a full-time wife and mother, and Bob continued working for *The Daily Herald*. As part of her daily routine, she would drive each afternoon to pick Bob up from work at the Herald offices on Water Street. One day she noticed a "For Sale" sign on what everybody called "The Old French House" at the corner of Magnolia and Water Streets, next to *The Daily Herald* office. "I would love to have that house," she told Bob. Before going home, they inspected the outside of the stately old home.

The next day, Mary called the listing real estate company, but found that the asking price was more than she expected. As she did before making any major decision, she met with Father Mullin and told him about the place. She told friends, too, like Vernon Pringle, who also

became interested in buying the house. Vernon's plans were to live in the residential part of the house on the ground floor and let Mary run a bar in the slave quarter section in the basement. While the three debated the pros and cons of the purchase, Jake and John Mladinich, who owned the Fiesta Lounge and a string of night clubs on West Beach, bought the place out from under them.

Mary was heartbroken. She later told friends she cried for days, and literally made life miserable for Bob and everyone in daily contact with her. No one could do anything to console her, not even Father Mullin.

But as in the past, fate and the Holy Ghost intervened. It seems the Mladiniches wanted to turn the house into a museum for a tax deduction and have tour groups brought there, but things didn't work out. In the meantime, a large parcel of land, suitable for an apartment complex, came on the market farther up West Beach, and the Mladiniches took out an option on the property. Unfortunately, a lot of their money was tied up in the purchase of the Old French House. In order to unload the property quickly, they wanted someone just to pick up the note.

The Old French House Venture Begins

Mary heard about the dilemma. She called Vernon Pringle, who said he had decided against buying the house. She then met Father Mullin at the Pastime Cafe to talk over the situation with him. He thought it was a good deal, and advised her to scrape the money together. Her father had reservations about the venture, but suggested she and Bob take her brother Andrew as a partner. Andrew was agreeable and sold his shrimp boat. With that money in hand, all they had to do was pick up a $13,000 note. Mary would later joke with friends that Andrew saved the money she had paid him to do dishes for her and used that for his part of the venture.

After the purchase was made, the new owners surveyed the house and courtyard, considering their options. Mary knew she wanted to put a bar in the slave quarter section, but asked Bob what they should do with the two-story house.

"We'll turn it into a New Orleans-style restaurant with a courtyard," Bob said matter-of-factly. Mary called her friend Glen Cothern to look over the place. Glen was the Budweiser beer salesman for the local Rex Distributors, and had befriended Mary at the Tivoli. Mary valued his business sense. "Do you think I can run a bar and restaurant?" Mary asked Cothern. His reply was what she needed to hear: "Mary, you can do anything you set your mind to do."

Mary immediately called Vernon Pringle and told him about the restaurant and bar she planned. Vernon wasn't exactly supportive. "For Christ's sake, how are you going to run a restaurant?" he asked. "You can't even boil water." Mary's father was also skeptical. He

argued that she didn't know anything about running a restaurant and she didn't even like to cook. "I'll hire the best cooks," she told him. But Tony warned her it was a bad idea to hire people who knew more about a business than she did. He also voiced his opinion against working on Sunday, which was reserved as family day. Mary promised, "We will never open on Sunday."

After winning her father over, the Mahoneys took on City Hall. The neighborhood was zoned residential, and there was some opposition to Mary's grandiose plans. Some residents opposed any kind of bar in the neighborhood, so Bob and Mary petitioned the Biloxi City Council for a zoning change before starting any renovations. The change from residential to commercial passed two to one with Danny Guice and Dominic Fallo voting in favor and Bill Dukate against. The way was now clear for the new owners to begin the restoration, which would take almost two years. It would be quite a project, but the partnership with brother Andrew proved to be beneficial for the work that lay ahead. Andrew was handy at building and repairing things.

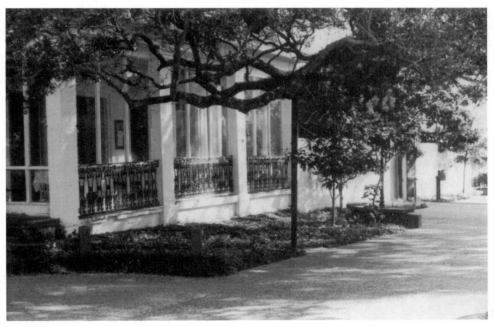

Front view of the Old French House facing Magnolia Street after undergoing renovation.

The Old French House had until 1962 been the home of Mrs. Byrd Enoch and had been in the Enoch family for the last fifty years. The home was built around 1737 on land that was part of a land grant to French colonist Louis Frasier (Fayard) who arrived in Biloxi in 1729. One previous owner claimed it was used as headquarters by Jean Baptiste Bienville when he visited the Gulf Coast while serving as governor of the Louisiana Territory.

The main house, which fronted Magnolia Street, consisted of four large, square rooms with fireplaces. All had the high ceilings, characteristic of French Quarter houses in New Orleans, and the floors were constructed of wide random-width boards of oak. A larger single room upstairs, which also had a fireplace and original floors, spanned the width of the house. The great room overlooked a walled court-yard, where a magnificent live oak dominated, shading the area.

The entire main house was constructed of handmade brick with wooden pegged columns of hand hewn cypress, and roofed with slate brought over from France. The porch facing Magnolia Street was floored with slabs of slate twenty inches square and more than four inches thick, which had entered the country as ballast in the boats of French explorers. The house contained a cellar—a rarity on the Mississippi Coast. The brick-walled cellar was so dry, previous owners used it to store books and furniture. Today, it is used as a wine cellar.

Detached from the main house by just a few feet were the original brick slave quarters. The structure closest to the house was apparently used as the kitchen for the main house, as indicated by the large fireplace. The second, which contains a smaller fireplace, was presumably the sleeping area for the slaves. The task of linking the south entrance of the main house to the detached slave quarter area fell to brother Andrew. "Mary always said I was a workaholic," said Andrew. "I was the painter, the carpenter, the electrician and the plumber." He used a mixture of lye and other chemicals to begin removing the years of paint from the house and shutters. He tore down a little inconsequential building in the back of the house to make way for the bathrooms and kitchen. He plotted out the new patio, and laid the bricks in the courtyard.

Father Mullin knew an architect from Vicksburg, Jack Canizaro, brother of local physician, Dr. Vito Canizaro. Canizaro agreed to

look the place over. He made suggestions on how to incorporate the unattached structures (referred to as the slave quarters) into the main house, and recommended placement for two small dining areas and bathrooms. Andrew recruited friend Charles Bailey to help him. They built a handsome mahogany bar that ran the length of the area now attached to the house. The old red brick walls of the slave quarter were kept intact, and each room was turned into charming dining rooms, complete with fireplaces, that flowed off the main bar.

Jerry O'Keefe toured the premises, too, and told Mary that gas was the best way to provide the central air and heat she would need for the restaurant. He put her in touch with a salesman for United Gas and helped her arrange the financing. O'Keefe also included the Mahoneys on his guest list when he hosted a dinner party in his New

A friend who came to overlook the property before it was renovated convinced Mary there should only be one entrance to the restaurant from the patio, and Mary should be there each night to greet her guests.

Orleans home for E. J. Ourso, an insurance company president. The contact proved to be a good one. Ourso asked Mary if he could tour the old house, and she, of course, was more than happy to show him around and hear his suggestions. During the tour, Mary explained that she was planning to have two entrances, one through the porch fronting Magnolia, leading directly into the dining rooms and another through the courtyard. "No," Ourso said emphatically. "That wouldn't be a good idea. You can give your guests more personal attention if you greeted them as they came into the bar from the courtyard." Mary loved the idea. There would be only one entrance to the Old French House—through the courtyard—and she would be near the doorway to greet her guests each evening.

While Andrew took care of the details of the restoration, Mary and her friend Bob Renker began combing the junk stores for bargains. Mary found old tables at the Salvation Army, chairs at Goodwill, lamps and assorted supplies there and yonder. She watched newspaper ads for restaurant supplies that might be on sale. She struck gold one day when she noticed that the old Miramar Hotel in Pass Christian was closing and auctioning off everything in the place.

Recalling the day on tape for friend Gail May, Mary said:

> "Bob [Renker] and I got there early in the morning before anybody else, because we were on our way to New Orleans to scout out things there. Well, I went just crazy! There were big cooking pots and deep fryers, iron skillets, large spoons, and forks. Crystal goblets were selling for ten cents on a dollar, and silverware for even less. We stocked everything we bought up in a pile, but we couldn't leave it and we couldn't fit everything in the truck either, so we called Bob and Steve Lyons to come over and pick up the things we bought, so we could still go on into New Orleans. I paid a guard to stand over my things until they arrived. I didn't want nobody going through my stuff. Oh! I had a helluva good time shopping that day. It was fun!"

That sewing machine Mary bought her sister Annie would now pay dividends. Annie had married LeRoy Clark, an Air Force officer, four months after Mary gave the sewing machine to her, and they were now living in Lakewood, Ohio. "Mary called us to tell us she and Andrew had bought a restaurant," said Annie. "She said it had floor-to-ceiling windows, and asked me if I would make the drapes if she took the measurements and sent me the material. So, of course,

I said I would." The project took about two weeks, Annie reports. And the drapes were lined, so they were heavy to mail. Annie also went to a restaurant supply place and found some 100-year-old Homer Laughlin plates for $1 each. She sent them on, too, "but they were so heavy, they cost about $2 apiece to ship," she laughed, recalling the fond memory.

The restaurant literally started on a shoestring. Mary couldn't even afford to have menus printed. So her good friend, Hilda, who worked for a local law firm, "borrowed" some long, legal folders. On the outside, Hilda hand wrote, "Mary Mahoney's Old French House Restaurant, Biloxi, Mississippi, May 7, 1964." She typed the menu and stapled it inside each folder.

Mary and Bob were also lucky to land one of Biloxi's top maitre d's. Joe Famiglio, who formerly worked for the Buena Vista and the Sun-N-Sand, was retired from the restaurant business—or so he thought. Mary convinced him to "please come to work for me." "Nobody could say no to Mary," Bob says with a laugh. "He couldn't make more than $100 a month on Social Security (and still collect), and I couldn't pay more than that," Mary later recalled in a newspaper interview. Famiglio helped assemble the experienced cooks and wait staff needed for the venture.

Before the official opening, Mary invited close, personal friends to the restaurant to sample the food. Annette O'Keefe remembers trying the corned beef and cabbage and cornbread. Jerry O'Keefe thinks he tried the meatballs and spaghetti.

By the Catholic calendar, Mary Mahoney's restaurant officially opened on Ascension Thursday, May 7, 1964. But it was a bittersweet occasion. Of great importance to Mary was making her daddy proud of her venture. But Tony Cvitanovich died March 18, 1964, less than two months before the restaurant opened.

Hilda Covacevich said the chapter recalling opening night should be entitled, "Suppose Nobody Comes." "Mary was a nervous wreck that night," Hilda recalls. "And she was driving everybody else crazy, too. A couple of the drapes were too long, and had to be hemmed. There were all kinds of last-minute things to do, and Mary was trying to do it all. All the time, she was worried, 'suppose nobody comes.'"

Mary recalled her opening night jitters in an interview years later with *Sun Herald* reporter Marie Langlois.

"Hell, I'm a gambler at heart," she said. "I had to be, to go into this business with no knowledge, no sense and no money. My God. I was scared to death. I was so scared, I had my husband Bob, my brother Andrew, and our son Bobby sit in the window at the front table so people going by would think I had customers. I was the bartender and the hostess that night, and I was half crazy. I thought, suppose nobody comes in, . . . we had about 108 customers that night and we've been filled ever since."

Bob fondly recalls a traveling salesman from Seattle, Washington, who just happened to come in on opening night: "His name was Paul Mor, and he told Mary he wondered why anyone would open a restaurant on a Catholic holiday, but after eating, he was convinced the restaurant would be a success. He wrote in the register, 'It's Ascension Thursday. The only way this restaurant can go is up.'" Bobby, Jr. says Mor's daughter came into the restaurant just recently. Her father is now deceased, but she teared up when she thumbed through the original guest register and found her father's message—still preserved as a cherished memento of that opening night.

A look at the opening night menu gives a glimpse of the state of the Mississippi Coast's economy. A shrimp cocktail was $1.00, and a fourteen-ounce sirloin steak with a baked potato and salad was $4.50. Iced tea was fifteen cents, and draft Michelob, thirty-five cents a glass. Originally, Mary had thought of opening a steak house, but her trusted advisor, Father Mullin, told her not to forget the wonderful seafood so abundant on the Gulf Coast. In expanding her menu, she remembered to include Slovonian cuisine, too. The most expensive seafood dish at the Old French House was Gulf Shrimp with Crabmeat for $2.75. Half a chicken with spaghetti and parmesan cheese was $2.25.

"We mostly winged it that night," Bob recalls. "Mary was running around like a chicken with her head cut off. She was so nervous. She had us all nervous, too." As the evening progressed, the place filled with diners, and Mary Mahoney's restaurant was on its way to becoming a local and national treasure.

Success Comes Quickly

*I*t didn't take long for the word to spread.

Mary's longtime friend and columnist Tommy Griffin wrote about the restaurant in his widely read "Lagniappe" column just three weeks after it opened.

> "Mary Mahoney, absent from the Gulf Coast scene for the last two years (when she lost her bar lease), is back in full glory with a bar and restaurant in the oldest home in Biloxi, which she has redone from stem to stern in elegant style. There's a slave quarter bar with little skillets for ash trays, and the whole thing has such a French Quarter touch. It looks like Mary is trying to extend New Orleans east another 85 miles. Her food. It's so good, she has a touch of the gout," he wrote.

Mary's vivacious personality and her flair for fashion, combined with her good food and personal service, soon put the Old French House on the "must go" list in a matter of months. In September, an article about the restaurant appeared in *Mississippi Magic*, a bi-monthly publication of the Mississippi Agriculture and Industrial Board, and circulated to top executives throughout the state. The restaurant soon attracted local executives from Standard Oil, Ingalls Shipbuilding, and International Paper, as well as businessmen coming to the Coast for conventions. That same month, news of the restaurant's opening was featured in *Deep South Magazine*, circulated throughout the southeastern United States. Mention of Mary Mahoney's Old French House appeared in the Sunday *Chicago Sun Times* in November 1964 in an article by travel writer Ken Ferguson.

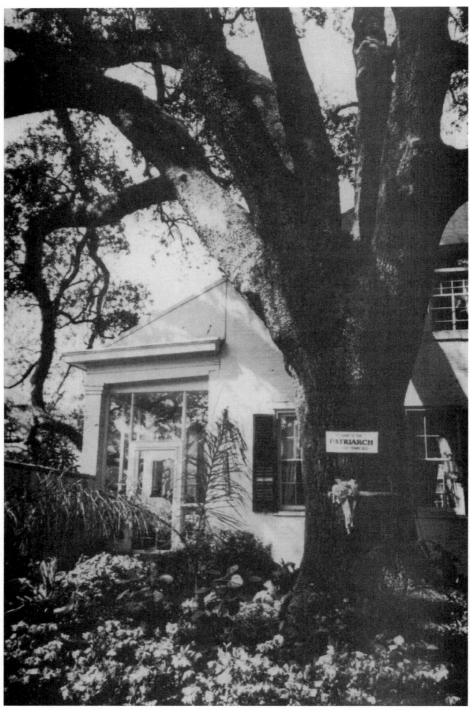

Mary celebrated and christened the giant oak in the patio "Patriarch" after a lumber expert determined it was over 2,000 years old.

In January 1965, *States-Item* columnist Griffin wrote, "Mary Mahoney—a-twitter 'cause fame of her Old French House is now as far flung as Chicago, New York and Connecticut, according to patrons."

The restaurant wasn't the only thing getting noticed. L. C. White of Greenville, Mississippi, was a frequent visitor in those early days. He was forest manager of Chicago Mill and Lumber Co., and he took a special interest in the towering and graceful oak in the courtyard. It had always been there, of course, but because this was a private home, with a wall blocking off the courtyard, most people didn't know it was there. White decided to do some measurements, and he informed a surprised Mary that he believed the live oak to be over 2,000 years old. That would mean it was there before Desoto's Conquistadors became the first white men to penetrate into the Mississippi Sound and before d'Iberville established the first white settlement in nearby Ocean Springs. Mary thought it cause to celebrate, and she invited her friends to the formal "christening." She broke a bottle of champagne across the tree's huge trunk and proudly baptized it, "The Patriarch."

In April 1965, only eleven months after the restaurant opened, Mary got an even bigger surprise: she was pregnant again. Tommy Griffin reported: "Nobody's more surprised than Mary. She thought she had an ulcer." Regrettably, Mary miscarried again. "She wouldn't slow down. She was so hyper," Bob said. Mary was deeply saddened by yet another loss, but she was determined to forge full speed ahead with her restaurant as soon as she regained her strength.

The Old French House celebrated its first anniversary in May with Mary serving cake and champagne to friends and guests. Soon the restaurant began attracting celebrities, too.

Paramount Pictures was filming "This Property Is Condemned" in nearby Bay St. Louis. Robert Redford came to dine, along with fellow stars Natalie Wood, Charles Bronson, and Kate Reid, a Canadian actress cast in the film. Mary and Bob developed a special friendship with Leonard Shannon, Paramount's press agent. Shannon was so enamored by the restaurant's food, he ordered several dishes to be flown back to the West Coast with him for a dinner party he was to host the upcoming weekend in California.

Shannon's note to Mary, Bob, Joe the maitre d', and Ginger (Harwell), Mary's bartender and co-hostess is still a cherished memento:

"You might like to know that you are responsible for the best dinner party here since Tony Curtis jumped out of the cake at Kirk Douglas's birthday bash. The full-course Southern feast rode back with the pilot from New Orleans to Los Angeles International and was on the Shannon table Saturday night when eight guests stuffed themselves silly and raised many glasses to all of you during the evening. Everything was absolutely superb; the blackeyed peas were perfect. The gumbo fantastic. The greens and okra great. The cornbread marvelous. I don't know what I can ever do to reciprocate, but when you do come this way, I'll sure as heck try."

Canadian actress Kate Reid told *Weekend Magazine* in Toronto, "It is possible to forget tomorrow eating soft shelled crabs at Mary Mahoney's."

Those in the restaurant trade came to Mary Mahoney's, too, to see what all the fuss was about, and Mary treated them as friends, not competitors. Elinore and Frank Moran of Commanders Palace in New Orleans came to sample the cuisine and ambience in August 1965, and brought with them Jake Rodosta and his new bride, Martha, who ran the famed Manale's in New Orleans.

Businessman John T. Fisher of Chicago was so impressed, he wrote *Holiday Magazine's* editor in 1965 saying, "I visited a superb restaurant in Biloxi that I feel should be considered for a Holiday award. I highly recommend the stuffed shrimp." Soon afterwards, the restaurant earned the coveted Holiday award.

Mary Mahoney's Old French House became a favorite of convention planners anxious to treat delegates to a unique evening out. The National Association of Homebuilders, with its 300 delegates, came in 1966. The Southern Paper Trade Association in May of that year was headquartered at the Broadwater Hotel, but convention planners made sure the ladies lunched at Mary Mahoney's.

Mary loved all the attention, and seemed to grow more sure of herself and her venture with each passing day. But the best was yet to come. The Old French House restaurant was featured in the winter 1966 edition of *Discovery Magazine*, the national publication of

Friend Vernon Pringle (shown here with Mary) mounted a successful campaign to get the Old French House featured in the prestigious Ford Times.

the Allstate Motor Club.

Mary had also won over one of her closest friends, Vernon Pringle, who began to mount a campaign to get the restaurant mentioned in the prestigious *Ford Times*—a magazine that boasted four million readers. The magazine's editor, Nancy Kennedy, wrote the Mahoneys in 1965, saying she would like to include the restaurant in a future edition. Finally, in January 1967, it happened—Mary Mahoney's Old French House Restaurant was featured in the section of the magazine reserved for famous recipes of favorite restaurants. The restaurant was pictured in a postcard-type layout with a brief narrative of its history, alongside the restaurant's recipes for Chicken Bonne Femme and Shrimp French House. Pringle remembers the presentation day like it was yesterday. "Mary was so excited," he said. "Of course, she had to go out and get a whole new outfit. And she planned the reception for weeks." Ford executives came down from headquarters in Detroit, Michigan, for the event, along with magazine personnel. "I wanted to do something special," Pringle remembers.

"So I called a local florist and told her to send Mary a bunch of orchids for a corsage. Well, when I got to the reception, there was Mary standing in the middle of the crowd. She had orchids draped from one shoulder, down her bosom, back up to her other shoulder. I said, 'Mary, my God! You look like you just won a horse race.' Everybody laughed, but Mary laughed the loudest. She was the only person who could get away with wearing something like that and still look elegant."

There was one honor that seemed to escape Mary in those early years, and finally, she set out to do something about it. On the tapes she made for her friend Gail May, Mary recalls numerous couples came into the restaurant and complimented her on the place and the food. Inevitably, they asked, "Why aren't you listed in Triple A?" the American Automobile Association Publication that rates restaurants. She tells Gail,

"This might have happened 100 or more times, and one night a nice couple was dining in the VIP room and complimented the restaurant and the food, and then the lady was about to ask something, and I stopped her cold. 'Stop, right there.' I said. 'I know your next question is gonna be, why aren't you listed in the Triple A?' I told them 'I don't know, but I promise you by tomorrow I will have an answer.'

"So, the next morning I drove myself down to the Edgewater Mall where the Triple A offices were, and I asked the young receptionist how I should go about getting listed in the Triple A. She said, 'Mary, I thought you were.' I asked her to give me the phone number of the President of Triple A, and I went back to the restaurant and put in a person-to-person call to him. The receptionist wanted to take a message, but I said I'll hold because I wanted to talk to him myself. Finally, he came on the phone, and I told him who I was and about my restaurant. He told me I called at an opportune time. They were just getting ready to publish their book for next year. He said he'd have us checked out, and 'if you satisfy our criteria, you'll make the book.' Well, I made it honey and nobody had to ask me that question again."

Time To Expand

*T*wo years after the restaurant opened, it was thriving. Mary, Bob, and Andrew knew it was time to expand. There was room to the rear and side of the courtyard. "I was thinking about building a giant bird cage in the courtyard and a small place in the back with maybe a wet bar," Mary told friend Gail May on tape. But Andrew had other ideas and Mary admitted later that Andrew's good sense won out.

Andrew went to New Orleans to look at French Quarter-style

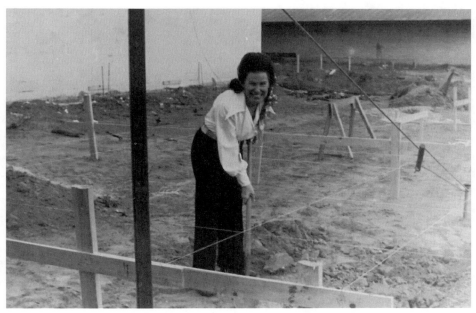

Mary turns the ground for the first expansion of the Old French House Restaurant, which would provide a carriage house and patio dining for guests.

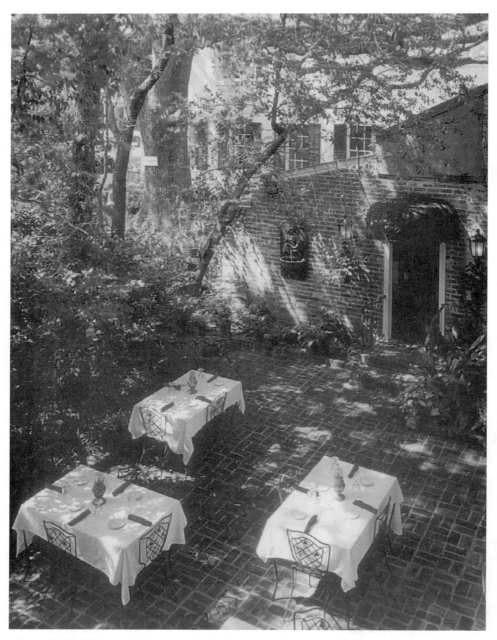

Hancock Bank featured the courtyard of Mary Mahoney's Old French House Restaurant in its 1998 calendar.

homes. He decided there was enough room to build a carriage house facing the patio for diners, and include bachelor quarters upstairs for himself. (He lived upstairs there until he married Mary Parker in 1966, just shy of his 39th birthday.) Andrew recruited friend Charles Bailey to help with the design plans. Mary and Bob thought Andrew's idea was wonderful, and plans were made. To fill the agreed-upon space, Andrew built an L-shaped structure of concrete, then plastered the outer walls. He added storm louvered doors to give the new addition the French Quarter look, and to the front of his upstairs quarters, he built a balcony overlooking the courtyard. The entire project was completed in about six months, and the restaurant then had space to offer accommodations for private parties. The new addition proved popular too, but while planning a patio luncheon for a group of ladies, Mary realized something must be done about "those bare, white walls."

Mary told friends numerous times the one thing her mother taught her was to invoke the help of the Holy Spirit when she was stumped or bewildered. In an interview with *The Sun Herald's* Mary Langlois, Mary said, "That's how the painting by local artists came to be on the walls of the carriage house. I was having a big luncheon for ladies, and the nice lady arranging it wanted it on the patio. Then she asked what I would do if it rained, and I said we could go inside the newly finished carriage house. She looked at it over her little pincnez glasses and asked, 'But, what are you going to do with those bare walls?' I said to myself, Holy Spirit, help me. And in a flash, I said, 'Why they will be decorated by Gulf Coast artists.'"

Mary was a known procrastinator, and months slipped by before she realized the time was nearing for the "ladies luncheon." She called Joe Moran, perhaps Biloxi's leading artist of that day, and promised him she would give him whatever he wanted if he could to something with those "bare walls." Moran told Mary he would coordinate a workshop for Coast artists. "You just supply the food and drinks," he said. Moran recruited members of the Gulf Coast, Singing River, and Biloxi Art Associations and Keesler Air Force Wives Art Club. The individuals gathered spent two weeks painting their own creations on the walls. In addition to Moran, featured artists included Josephine Alfonso, Abe Smiles, Thornton Smith, Louie Graff, and

Mary recruited several artists from the coast to paint murals, such as this one by Evelyn Husley, on the walls of the restaurant's carriage house. Works by the late Joe Moran and Josephine Alfonzo also grace the walls. The collection is now considered an historic treasure.

Evelyn Husley. Husley, a dear friend who attended school with Mary, spoke about the origin of the painting in an article that ran April 21, 1996, in *The Sun Herald:*

> "It was a lot of fun to be part of. We would stop for lunch, then come back and work some more. It is very historic, and I'm proud to be one who was asked." Husley's son, Val, said, "At the time it was done thirty years ago, it was the greatest collection of art on the Coast. If something happens, those walls have to be saved."

Mary admitted the paintings were done two days before the ladies arrived for their luncheon. Today, the thirty-three original oil paintings by Gulf Coast artists that were lovingly painted thirty years ago are permanently displayed on the walls of the carriage house for generations to enjoy.

Years passed, and the restaurant grew more prosperous, but Mary still had not taken an extended vacation. She heeded her father's words that "nobody's going to take care of the business like you." Sure, she

would go to New Orleans for the opera and plays and the New Orleans Saints games, or she would travel to Mobile to catch a traveling Broadway road show. She was always happy to patronize the theater and cultural events in Biloxi and other places along the coast, but she was rarely away for more than a few hours or a few days at a time.

Bob tells a wonderful story about them taking a long weekend to be by themselves in New Orleans. "I think we were celebrating our anniversary, and we booked a suite at the Monteleone Hotel on Royal Street in the heart of New Orleans. It was where we had spent our honeymoon, and Mary loved that old hotel. We were going out on the town that evening, and I got a little tired of waiting for Mary to get dressed in the room. So I told her, 'Take your time, I'm going down to the Carousel Lounge [in the hotel]. Just meet me there.' So I'm having a few drinks, talking with the bartender when Mary comes to the door. Although it was still daylight, the bar was darkened, and Mary—dressed in her finest and with a big hat on—was kind of standing in the doorway, squinting her eyes to adjust to the lack of light, and looking for me. Well, the bartender looked up, and saw Mary standing in the door. I guess he thought she was a hooker or a Madame or something. And he said, 'Get a load of that sack of shit.' I told him that sack of shit belonged to me. He almost crawled under the beer bin. He was so embarrassed. Mary came and sat next to me, and I told her what happened. And the bartender apologized profusely. Mary got a big laugh out of it, too, and before we left, she made the bartender feel at ease, and they parted friends."

After Mary's restaurant had been open a few years, she did manage to go and visit her sister, Annie. She was living in Lakewood, Ohio, and told Mary the town was loaded with antiques that were reasonably priced. There were treasures to be found at the local Goodwill and Salvation Army stores, Annie said. "Mary flew into town, and we went on a three-day shopping spree. Mary picked up a chaise lounge, some old chairs, an antique dining room table and God knows what else. Of course, she couldn't bring all those things back on the plane with her, so she started calling around to various moving companies and was told they would charge her the same price to deliver one pound or 500 pounds of furniture to Biloxi. That's all the incen-

tive Mary needed to buy more. My husband came home surprised to find Goodwill delivering stuff to our house instead of picking it up." The furniture and other items stayed stored in the garage on Annie's property for about three months until the moving company had a load going to the Mississippi coast and came to pick them up.

Mary visited Annie and her husband, Roy, later, after the restaurant was enjoying a national reputation. "I remember she came to visit us one time when we were living in Mitiwanga Park, Ohio. Whenever we'd go out, she'd ask to meet the owner of the restaurant or the chef, and she'd pass out her little menus or souvenir pens, and, of course, she would invite everyone to her restaurant. She never met a stranger, and everybody who met her absolutely fell in love with her."

It wasn't until the earlier part of 1969 that Mary began longing to see her relatives in Yugoslavia, whom she had never met. She made plans and set off for Tresteno, her mother's birthplace. There, Mary visited Uncle Niko Trojanovich, his wife, Maria, and their two sons, Miho and Georgo. Niko was still a baby when Mary's mother immigrated to Biloxi, and now he was a grown man with two sons. Mary

The Mahoney's home on east beach in Biloxi was destroyed in 1969 by Hurricane Camille, never to be rebuilt.

was saddened by their poor living conditions and their poverty, and convinced Uncle Niko he should give up farming and come to work in her restaurant.

That same year would be a watershed year for the Mahoney family, setting their interests off in several directions. In August of 1969, Hurricane Camille struck the Mississippi Gulf Coast, wrecking havoc from Bay St. Louis to Biloxi. The storm caused millions of dollars in property damage and claimed hundreds of lives in its trek across the southeastern United States.

New Orleans and the Gulf Coast had ample warning since the storm was born out of a low pressure system that formed off the coast of the Yucatan Peninsula in Mexico, but Camille's erratic behavior kept even the weather experts baffled as to where its powerful eye might come ashore. Days before the storm hit, businesses and property owners from New Orleans to Florida were boarding up windows and tying down whatever could be tied down, and hundreds were fleeing the approaching storm, evacuating north to Hattiesburg and points beyond.

The Sunday night Hurricane Camille reached Biloxi with winds topping 200 miles an hour, the Mahoneys and their extended family were holed up in their beachfront home next to the Biloxi Hospital. With Mary and Bob were daughter Eileen, Bobby and his wife Sandy, Sandy's mother and father, Ruby and Bob Smith, family friend June Bru, Mary's mother, and Hilda Covacevich. That Sunday afternoon, Mary and June busied themselves preparing the family dinner. Everyone was listening to the weather reports on television, but nobody knew where the hurricane was going to make landfall.

Eileen was all of 13, but she remembers the night Camille came ashore as vividly as though it was yesterday. "The water started coming in through the front doors, and me and Bobby started putting towels under the doors. When the waves would bring the water surging into the room, we'd ride the towels back about 10 feet. The adults weren't too concerned. They were having a hurricane party and the booze was flowing. Everyone thought the water was going to come into the downstairs portion of the house, then recede, but once the water started filling up the living room, the whole group was forced to flee upstairs. Now we were scared. The water kept getting higher,

and we fled into the attic. When the water got to the eight or ninth stair leading to the attic, we all got pretty nervous. We were trying to figure out how we were going to get grandmother out on the roof."

Eileen said Bobby had a flashlight and as he shined it out of the tiny attic window they saw a big oak tree fall and break off the whole front of the house. "Bobby started leading everybody in the rosary. Nobody knew he even knew how to say it," she remembered.

Eileen remembers the winds subsiding and the water slowly receding out of the house. It was near daylight when the weary party came down from the attic and ventured outside. There was little left of the beautiful family house on the beach, except the memories that a storm could not erase. "I didn't even have on a pair of shoes," said Eileen. "I wore Bobby's Army National Guard boots, and I had on a Saints T-shirt and some ugly polyester shorts. That's all I had to my name. But we were all happy to have survived."

The weary homeless made their way down the beach, and up Magnolia Street to see what was in store for them at the Old French

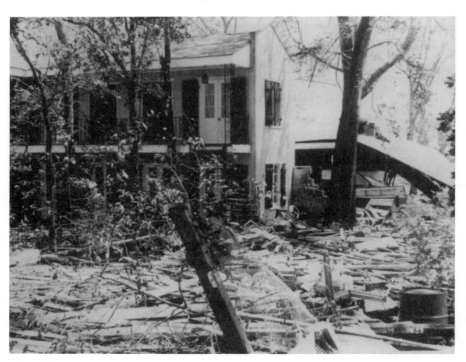

The Old French House escaped major damage during Hurricane Camille. This is a view of debris in the courtyard.

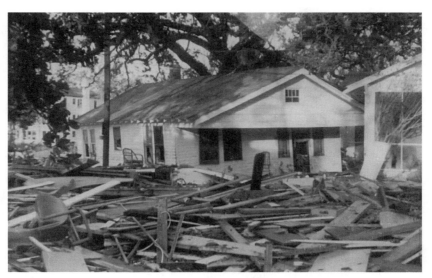

This view shows the Old French House Restaurant with its side facing Water Street, and the havoc caused by a tidal surge following Hurricane Camille.

House Restaurant. Amazingly, the restaurant had sustained little damage. Of course the courtyard was a mess with fallen limbs and lawn furniture that had been tossed about, and the water had come inside the bar. But the sturdy old house withstood the fierce winds and tides. "I remember, we all slept on the tables at the restaurant for a couple of nights," said Eileen. "Then when the roads were cleared, a friend took us to New Orleans by way of Hattiesburg, and we all went shopping at J. C. Penney for new clothes and spent a few nights at a motel there somewhere."

Roland Weeks, Jr., now the publisher of the *Sun-Herald*, remembers going down to the Old French House a few nights after Camille had hit "to see if there was anything left." He saw a light coming from the slave quarter bar.

"Mary and a few friends were there sharing experiences, but also planning for the future," said Weeks. He said he had been depressed by the death and destruction all about him. But Mary's optimism and cheerful bravery in the face of adversity inspired him and many others to stand up to the cleanup that lay ahead and to begin planning for the future.

The cleanup began. Mary's friend Jimmy Balthorpe, who lived

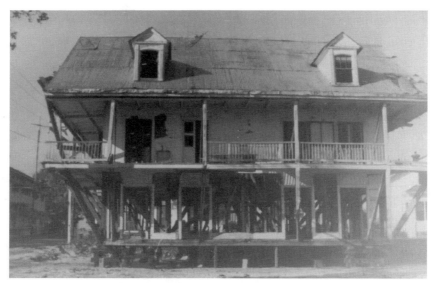

The Old Magnolia Hotel across from the Old French House Restaurant was destroyed by Hurricane Camille, but later restored by the City of Biloxi. Many friends credit Mary Mahoney for igniting downtown restoration.

nearby in the Spanish House on Water Street, had a gas refrigerator, so "Andrew and everybody came over and used it," he remembers. "Mary took it on herself to feed the electrical crews and other repairmen working in the cleanup. If they had money, they'd pay for lunch. If they didn't, that was okay, too." The Mahoneys moved into temporary residences at the Gulf Towers high-rise apartment building on the beach.

The Old French House was closed only about four or five days. It and the restaurant in the Buena Vista Hotel were the only ones left along the Mississippi Coast, where more than a dozen, like Baricevs and the Friendship House, had enjoyed loyal followings for years.

Hurricane Camille had destroyed a shotgun house that was right next door to the restaurant and the VFW and an old filling station at the corner of Magnolia and East Beach Streets. The city bought the property, cleared it, and used it for a parking lot. Two years would pass before Mary and Bob and Andrew would approach the city with a purchase offer. Andrew knew exactly what he wanted to put there.

Andrew used old brick and designed and built a 24-hour restaurant called Le Cafe. It would serve New Orleans-style café au lait,

and hearty breakfasts to those ending a late night of drinking, or those who wanted breakfast before going to work in the downtown stores. There would be New Orleans-style po-boys for lunch and dinner specials. Mary recruited a local artist to paint the murals on the walls of Le Cafe. The murals pay special homage to annual events on the Coast that celebrate Mardi Gras, the Blessing of the Shrimp Fleet, and St. Patrick's Day.

Next door, Andrew planned the Irish Pub. It became a place where late-night drinkers could go after the restaurant closed. It would later serve as the center of activity on St. Patrick's Day after Mary and her friend Glen Cothern founded the Hibernia Marching Society, giving birth to Biloxi's first St. Patrick's Day Parade.

Behind the Irish Pub, Andrew put in another patio, with shops below and three residences above: one for Mary and Bob, another for Bobby and Sandy, and one for himself.

Mary took charge of getting tenants for the downstairs shops, and she opened one herself. She called it Mary's Mexican Market. The shop gave her a good excuse every now and then to grab a bunch of friends and fly down to Merida and other lesser known places in Mexico "to stock her shop." Grace Gruich, wife of Mary's physician and friend, Dr. Frank Gruich, recalled that she once accompanied Mary on a buying trip to Merida. "She showed up at customs on the way out with fifty dresses for her shop. The customs official counted them and looked up rather sternly at Mary," said Gruich. "He asked Mary why she was bringing so many dresses home, and Mary's

Mary strikes a movie star pose on one of her many buying trips to Mexico.

reply was, 'I always keep fifty dresses to wear. Doesn't your wife have fifty dresses?' When the officer said no, Mary tried a new tactic. She invited him and his wife to come by and visit her restaurant. She got the dresses through."

Mary talked her good friend Anna Wilkinson into minding her store after she got off work each afternoon at City Hall. Anna's husband, Bob, had been bartending at the Old French House since 1968. "Mary didn't really care what I did," said Anna. "I'd work a couple of hours and could sell anything I wanted, for what I wanted."

Mary talked another friend, Gail May, into opening a shop which May called "The Gold Connection," in the Irish Pub mini-mall, too. The women become even closer friends after this venture.

It wasn't long after the Irish Pub opened in 1971 that goings on there also made the news. Mary's favorite columnist, Tommy Griffin, was there the night somebody streaked the place. He called the "hot item" into the newspaper, so it could appear in his popular "Lagniappe" column the next day. "My Gosh!" Griffin wrote. "A streaker in Mary's Mahoney's cocktail bar in Biloxi. A man came out of the gent's room nude, streaked through the crowded room, through the patio into a waiting car. Streaker came back fully clothed later, and a young woman tipped him $5 saying, 'You were worth it.'" Others in the crowded bar bought the streaker drinks, gave him a T-shirt, and lit a candle to him.

That streaker was Claude Payne, who was working at one of the hotels on the Coast and who frequented Mary's with Stephen (Buzzy) Sekul, the son of city judge John Sekul. "That night, Donnie Vaughn was with us, too," Claude remembers. "And this guy had just streaked the Academy Awards show, so Buzzy put me up to it. He went with me to the back men's room, took my clothes, and said he'd have his big Cadillac outside running and waiting. So I did it. It was a hoot. And when Mary heard about it, and found out it was me, I couldn't buy a drink there for months. She'd always say, 'This one's to the streaker, on me.'" Payne has framed the clipping of Griffin's column, and it has graced his walls, moving with him from place to place, for more than twenty years.

While Mary was thrilled about the new addition to her growing empire, she never forgot her first duty: to greet those who came to

dine at the Old French House, paying special attention to her local clientele. Mary was always young at heart and she took particular interest in the local young men and women who came to her restaurant and slave quarter lounge on a regular basis. Among her favorites were Jean Moran and Vincent Kuluz. "Just kind of off the wall, one night, I asked Mary if we could have our wedding reception in the patio," remembers Jean. "There had never been one there before. Mary was thrilled with the idea, but said the day we wanted would be very busy. There was a large luncheon around noon and another large party that night. I told her we'd work it out between lunch and dinner, if she promised it would be overcast, because I didn't like standing in the sun with the bridal dress and everything else on," said Jean.

The couple was united in marriage at St. John's Catholic Church on Lameuse Street on June 26, 1971. The bridal party and guests then drove to the Old French House. Mary had the drinks and hors d'oeuvres all set up for the happy occasion. The day was not dreary, but it was overcast; Mary hugged the new bride and whispered in her ear, "You got your wish."

Shortly after the Le Cafe and Irish Pub were opened, another opportunity arose for the Mahoneys. *The Daily Herald* newspaper (which backed up to the restaurant's rear) built a new printing plant on DuBuys Road and closed its downtown doors. By this time, the Mahoneys and *Herald* publisher Roland Weeks had become good

Son Bobby Mahoney, Jr. poses with the "Queen of Bourbon Street," New Orleans entertainer Chris Owens.

friends. In fact, Mary was godmother to Week's daughter, Alex.

The Old French House acquired the *Herald* property in July 1972.

"Thank the good Lord we got that property," said Andrew. "We were cramped for space, especially in the kitchen." Andrew opened up the back wall adjoining the Herald building for more dining. Originally called the Herald Room, the addition is now renamed for Mary's good friend Glen Cothern. It provides enough space to hold large parties. The rest of the sturdy old building was transformed into a new state-of-the-art kitchen, with its own laundry room and dishwashing area. The back alley was turned into a receiving area. The second floor was used for storage and expanded office space.

The side of the Old French House facing Water had been used for parking, but Andrew didn't think the space was being used to its fullest potential. In 1978, the area was cemented, and Andrew began building the Sun Room, with floor-to-ceiling windows that looked onto the street. Mary put in hanging ferns and hundreds of evergreen plants. She was delighted with the outside garden effect of the new room. She had more domain to roam when greeting her adoring public. This latest addition increased seating capacity for the entire operation to about 340, Andrew estimates. It has helped keep the restaurant competitive and thriving.

Looking back on the whole venture, Andrew concedes, "It was a roll of the dice. Mary and I never were in the restaurant business. We didn't really know anything about it." Andrew readily attributes some of the restaurant's initial success to Joe Famiglio, the maitre d' whom they lured from the Buena Vista. "My Dad told us never to get into a business where the help knew more about it than you, but that's exactly what we did," said Andrew. "We were very, very fortunate that he was there to help us." Mary looked back, too, when writer Linda Sanders of the Jackson, Mississippi *Clarion Daily Ledger* newspaper profiled People in Business in a 1982 article. *The Mississippi Business Journal* and the U. S. Small Business Administration selected Mary Mahoney as Mississippi's Small Business Person of the Year in 1982, and she was honored, along with others from across the nation, in a Rose Garden ceremony on the White House Lawn presided over by President Ronald Reagan. The plaque saluting Mary's accomplishments hangs proudly in the restaurant. It applauds

Mary "for exemplifying the imagination, initiative, independence and integrity by which the small business person makes a vital contribution to the nation, the economy and the free enterprise system." In accepting a similar honor in Mississippi, Mary said, "I would hope . . . to be an inspiration to a lot of young people who do not have the knowledge, but who do have the desire. Sometimes desire can be a lot more important than anything else."

In *The Clarion Ledger* interview, Mary said the personal touch was what contributed to the success of her restaurant. "My philosophy is people are the most important thing," she told Sanders. "People come back and tell me, 'We had our wedding reception here' or 'We ate here five years ago.' Word of mouth is really our advertising." Mary admitted she sometimes carried her philosophy a little too far. "Once I realized I let a couple leave without giving them anything. I chased them into the parking lot with a pair of coffee mugs, but it was too late. I felt just terrible," she said. Mary gave full credit for the restaurant's success to her husband Bob, brother Andrew, and her maitre d' Joe Famiglio. "I can't say enough about how much my husband helped me," Mary told Sanders. "He suggested the restaurant. He'd run over at lunch from *The Daily Herald* office, tend bar, keep the books and work at night. He and my brother Andrew kept

Bobby Mahoney poses with the late Governor John Connally of Texas.

things going. Andrew does all the outside landscaping and work, and I tend to the inside. My husband has always backed anything I wanted to do. I just lucked out and married an Irishman from Pennsylvania. When you go from a name change like Cvitanovich to one like Mahoney, you are lucky."

She also admitted to Sanders how much she loved her business. "On Sundays [when it's closed] I sometimes look out over the restaurant and patio, and I have the greatest urge to go down and open up," she said. "This is the only time I ever feel a bit depressed. God gave me great enthusiasm for living and doing things."

Mary celebrated the restaurant's tenth anniversary by taking out an ad in *The Daily Herald*, thanking friends and customers for the success of the Old French House. Her message read as follows:

> Today, as we celebrate our tenth anniversary, I would like to share my thoughts with you. Ten years ago, we gambled everything we had and could borrow on the good taste and the good sense of the people of this metropolitan area. Unknown and unheralded we opened in an old and hard to find but handsome cottage. We gambled that the people of this area had the good taste to appreciate our cooking, and the good sense to find it, wherever we were. Thankfully, you proved us right, on both counts.
>
> So this comes as a love letter to all of you. Thank you! Thank you! Your encouragement and your truly magnificent support have gladdened our hearts and inspired our imagination, and if many now, locally and nationally, call us this area's premiere restaurant, it is only because you wanted it so, and we have striven to make you happy. It is not enough to be merely a good restaurant, a restaurant must dare to be more. We have been blessed in the past with people like Mr. Joe Famiglio and Mr. Elizah Scott, who are now retired. We are blessed now with a loyal and attentive staff, and our suppliers are all honest and decent men who sell only the best. No restaurant could be more fortunate. As we enter our tenth year, we count our blessings and the Cvitanovich and Mahoney families have come to one conclusion: You are our blessings—our friends and customers. We look forward, with God's help, to a future happy and content and eager to serve you.
>
> My most sincere thanks,
>
> Mary Mahoney

CHAPTER 7

Mary Goes to the
White House Lawn

*I*n 1979, Mary started out on a new adventure that would eventually lead her to the White House lawn to feed the President of the United States, but she didn't know it then. Over the years, Mary had become a supporter and good friend of U. S. Rep. (now Senator) Trent Lott. He convinced her to come up to Washington in the Spring of that year and put on a feast for the entire Mississippi Congressional Delegation. The event was to be sponsored by the Mississippi Department of Agriculture and Commerce. Always ready for any new adventure, Mary jumped at the opportunity, although she told friends later, "I didn't know what the hell I was getting into." Mary depended on her nephew, now chef, Georgo Trajanovich, to prepare the menu and "volunteered" faithful employee and cook Gladys Daniel to make up the seafood gumbo the night before. On the morning Mary was preparing to pack all the food for loading on the plane, she noticed the gumbo had gone sour. She panicked, calling all over town for Gladys. Gladys told her, "Don't worry. Bring everything. We'll cook it up there," and they did.

The parties that Mary catered in Washington became legendary, with more and more people wanting to crash the annual event at the Rayburn Office Building. Naturally, when the National Fisheries Institute teamed up with the Mississippi Department of Agriculture and Commerce to host a Southern-style seafood fest on the White House lawn in 1984, Mary was at the top of the list of restauranteurs invited to cook for President Reagan. June 22 was warm and balmy in Washington, D.C., and the spring air on the White House lawn was filled with the smell of catfish, salmon, and crab. Mary, along

Mary gets a glimpse and later a personal thank you from President Ronald Reagan after serving a Southern-style feast on the White House lawn in 1984.

Mary poses with Senate Majority Leader Trent Lott, R-Mississippi, on the White House lawn after serving the President and selected Congressional and Cabinet leaders in 1984.

with chef Georgo, Gladys, and another trusted aide, Ellen Williams, prepared and served crab claws rolled in cracker crumbs and flour-breaded baby softshell crabs. The Charlie Daniels Band played when the President and his daughter, Maureen, neared Mary's area. Mary was prepared to be both cook and photographer, wiping her hands on her apron as she grabbed the camera that hung around her neck. Mary

had taken a tape recorder to the event, and she taped her thoughts shortly after seeing the president and having her picture taken with him. "It was really very exciting. One of the fellows helping us said, 'Mary, turn around.' And, when I did, there was the President. I got so excited. We got our picture taken with him." That picture was eventually personally autographed by President Reagan, and remains today a prized family possession. It resides in a prominent place of honor, in a glass case outside the restaurant's south entrance. Mary had also snapped pictures that day on the White House lawn of Vice President George Bush and his wife, Barbara, and Rep. Trent Lott and his wife, Tricia. Everyone who knew Mary knew she was a die-hard Democrat, but she did admit, "I'm one of those who likes Ronald Reagan."

On the tape recording Mary made that day, she gave credit for the success of the event to everyone except herself. About her staff, she said:

> "Hell! I don't amount to worth a damn, but the people I'm taking up with me are great. If a bomb dropped, they wouldn't miss a beat. And all the people who were involved tonight—they couldn't have been much nicer. Everybody was just so helpful—the White House people, the National Fisheries people—just everybody involved couldn't do enough to help everybody. And everybody told us it was one of the nicest affairs they had attended at the White House in a long, long time. We were only one of two restaurants there, and I think that was a big honor. All my help just adored it. They were just all so excited. I think it was one of the greatest things we've ever done. On the whole, it was just a great, great night."

Outwardly Mary appeared on top of the world, but there were signs in early 1984 that something was wrong. Hazel Pitalo remembers an occasion at a carnival ball: "We went to the ladies room together and Mary started slurring her words. We were drinking, but Mary could hold her liquor. In all the years I've known her, I never saw her drunk to the point that she had trouble talking. She felt dizzy, so we decided to go home." In March 1984, Mary joined Bob's brother, Father Bud, and his friend Brother Herman E. Zaccarelli, director of Purdue University's Hotel and Restaurant Institute, on a trip to Austria. They promised she'd be back before the annual St. Patrick's

Day celebration on the mall outside the Irish Pub. Daughter Eileen picked Mary up at the airport in New Orleans. "When we got back home, mother got out of the car," Eileen remembers. "She got some things out of the back of the car, then she slammed the door. Then she kept opening the door and slamming it shut again. I thought she had jet lag."

Gail May remembers walking in the courtyard with Mary shortly before the St. Patrick's Day celebration got underway. "Mary told me she felt 'goofy,' which was one of her favorite words. She said she felt dizzy, and thought her eyeglasses were going bad. She couldn't even walk a straight line." Mary had a habit of picking up and wearing glasses left by anyone at the restaurant or buying off-the-rack reading glasses. This time, she went to a local opthalmologist to have her eyes examined and stronger lenses prescribed. But the dizziness and slurring continued. And sometimes she'd be speaking and lose her train of thought. She put off any further diagnosis until around November 1984 when relatives convinced her to go into Ochsner Hospital in New Orleans for a CAT scan. The prognosis was grim, but there was hope. Mary had a glioblastoma—a tumor on the brain. Surgery would be needed to remove it, and if it were malignant, she would have to undergo chemotherapy treatments. Mary, who was rarely sick, braced herself for the worst. She feared she would not live to see the birth of daughter Eileen's second child, whom she already knew would be a boy.

CHAPTER 8

Mary's Illness, Death

*B*efore her initial surgery, Mary wrote a poignant and loving letter to son Bobby and daughter Eileen from her bed at Ochsner Hospital, November 27, 1984. She told them if anything happened to her, "Please do not let them put Maw Maw [her] in a nursing home." She also instructed Bobby and Eileen to remember all her friends by picking out a memento for them.

> "Let Barbara and June see if anything fits them," she said. "Give Uncle Niko, Maria and Georgo my love and some money for the church in Tresteno. My love to Daddy. You Bobby, my first flower, my baby, Eileen, my brother, Andrew, who has done so much, my darling sister Annie, my beautiful grandchildren, my dear, sweet mother, and all the rest of my family in Biloxi, New Orleans, Buras, Bellechase, and Yugoslavia.
>
> "Please do something nice for Jerry Stafford. She was so good to me when Bobby was little."
>
> She instructed Eileen, "There is a beautiful evening bag that Gail (May) gave me. I would like for you to give it back to her, and something else that you think she might like."

She gave special advice to grandchildren, Stacy, Caty, Trae, and Nicole and told Eileen she thought the baby she was waiting for would be a boy. Always the businesswoman, Mary also instructed Bobby and Georgo to "work on doing something with the gumbo. I know it would sell." She gave instructions on what paintings to keep in the restaurant, and where to find the abstracts of their property on the beach.

In a letter the following day, her spirits were more buoyant. Her

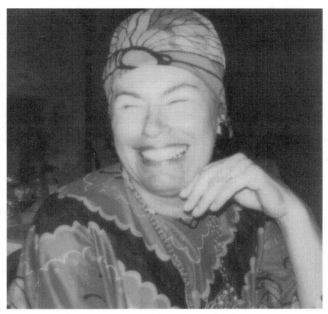

Following chemotherapy, Mary used wonderful scarves and matching outfits to hide her hair loss, and she always remained the optimist.

room was filling with flowers from Bobby Bell and Harry Clark; Annette and Jerry O'Keefe; the law firms of Page, Mannino, and Peresich; Denton, Persons, Dornan, and Bilbo; friends Beverly, Alice and Elda; Dickie, Rose, and Franklin; Jan Schwarz; Jordy and Darlene, and George and Cindy. She received "loving messages from Maria, Randy, Dave and Barbara and Georgo, Debbie, Uncle Niko and Maria."

Mary wrote: "Annie, Roy and Margaret came over and we went down and had lunch, but first we went to the bar. By the way, I had my doctor's blessings to have a martini—cheated, I had two. I needed them because right after lunch, I had a rear end exam—no fun."

Later that Sunday, Mary was visited by Andrew, Mary, Maria, and Niko. They all went down to eat lunch about 12:15 p.m. Mary wrote afterwards, "The bar was not opened yet so we went later and we had a couple of scotches." Bob, Bobby, Eileen, Caty, and Stacy arrived after Andrew left. "They had gone to [cousin] Drago's to eat, and brought me something back," she said.

There had been a minor rift between Annette O'Keefe and Mary, which sometimes happens with close friends, but Mary wrote, "My most surprising call was from Jerry O'Keefe. It was such a surprise, and he sounded so good. I guess out of something like this, something good happens. I am so happy. I had a beautiful letter from Annette today. I love them both so much." She closed the letter saying, "If something should happen, I would like you to select the waiters [for pallbearers] that have been with us the longest. Give everyone at the French House my love."

Mary survived the initial surgery and after a few weeks in the hospital and chemotherapy treatments, she returned triumphantly to her loving family and the restaurant she loved. She complained publicly later, "I ain't got no hair," but she couldn't wait to regain her strength, get all dressed up again, and greet her adoring public.

The Biloxi Chamber of Commerce later elected her the first woman president of the Chamber in 1985, and chairman of its Committee for the Year 2001. On December 23, 1984, grandson Josh was born, and Mary thanked the Good Lord for allowing her to be around for that blessed event.

Mary was planning to meet her sister, Annie, and brother-in-law Roy Clark in Washington, D.C., in June 1985. Annie and her husband, both avid sailors, were taking their catamaran to Annapolis, Maryland, and they were to meet Mary in Washington, D.C., at the home of Mary's friend, Jan Schwarz. "I called Jan, and she said, 'Mary's not coming,'" remembers Annie. "'She had to go back to Ochsner again for more surgery.'"

Again, Mary came out of the hospital, but the prognosis was not good. The tumor had returned and was spreading. She would require more chemotherapy, and with each treatment she would grow a little weaker. By late summer 1985, Mary had taken to her bed and had to be helped to dress and eat. She became more reclusive, spending more time in her apartment, but sometimes came out into the courtyard to sit and talk with her friend Hazel Pitalo.

Friend Eddy Ally stopped by the apartment on occasion to see her and bring her "Chinese Chews." Other close friends, like June Bru, were also allowed to visit. Doctors declared there was nothing more they could do.

In the fall of 1985, the mayors of cities from across the Mississippi coast proclaimed Sunday, September 22 as "Mary Mahoney Day." A crowd of more than 300 of her closest friends turned out in the restaurant's courtyard to honor their dear friend.

From the balcony, the Port City Jazz Band played "Ja-da, ja-da, ja-da, ja-da jing, jing, jing," "Pennies from Heaven," and "Basin Street Blues." Among notables gathered with the coast mayors were the Most Rev. Joseph Howze, Bishop of the Catholic Diocese of Biloxi; Maj. Gen. Thomas Hickey, Commander of Keesler Air Force Base; Oilman Fred Larue of Ocean Springs; New Orleans developer Joe Canizaro; and Roland Weeks, president of Gulf Publishing Company.

Weeks remembers going to see Mary in her upstairs apartment before the ceremonies began. "She was all dressed up, and sitting in a chair. She seemed frail and weak. It was like she was saving her strength to greet her public for the last time."

After the rousing roaring 20s salute by the jazz band, Mary emerged from the wings, stealing the show, in her white-on-white silk dress, draped jacket, and black accessories. Mary's trademark eager smile put her adoring public at ease. "I'm overwhelmed at all the hurrah," she said. "I am in debt to all you beautiful people. God loves you. I love you. We love you, and just be good."

A live oak was planted that day in front of the Magnolia Hotel across the street from the Old French House. It stands today and carries the following inscription:

> "The live oak, a God-given treasure, is a creation of beauty and strength, as you are, Mary. We shall be planting this live oak in your honor because, like you, it is a symbol of Biloxi, spreading its shade as you spread your kindness and joy; bending to the winds of adversity, yet always standing strong.
>
> With greatest respect and love,
> Fellow Citizens of Biloxi."

Mary grew weaker with each passing day, and by mid-November had to be taken by ambulance to Biloxi Regional Hospital. Bob, Mary's children, and friends like Hazel Pitalo and June Bru took turns at her bedside, although she had slipped into a coma.

Mary died in her sleep Sunday, December 29, 1985. June Bru, who lives in Mobile, recalls the day, saying she still feels badly about not being by her friend's side. "I woke up Sunday morning," she said, "with the idea of driving in to see Mary. And, you know how life is. Something came up, and I didn't go. Then Eileen called me Sunday night to tell me. I was just crushed." Although it was expected, the news hit everyone hard, particularly Mary's brother, Andrew, who had celebrated his 58th birthday the day before.

The local television station, WLOX, broke the news at 10 p.m. and followed up the next day with interviews outside the restaurant with son Bobby and prominent local officials and others who knew Mary Mahoney. They interviewed Dr. Frank Gruich, Mary's personal physician in Biloxi and a longtime friend. Said Gruich, "She was very, very optimistic about the city of Biloxi's future, the waterfront development and the tourism industry. She was always speaking positive about Biloxi. She used to always tell me, 'I don't want to hear no negatives about Biloxi.'" Former Biloxi Mayor Gerald Blessey credits Mary with sparking the revitalization of downtown Biloxi. "The Old French House was probably the first real restoration project downtown," said Blessey. "That saved a lot of other buildings from being torn down." Son Bobby likened Mary to a starting quarterback of a Super Bowl football team. "All the elements could be in place, but without the quarterback, there would be nothing," said Bobby. "She is our irreplaceable quarterback." Mary's death was noted in several regional newspapers, including the New Orleans *Times Picayune*, the *Mobile Register*, and the Jackson *Clarion Ledger*. It also appeared on the front page of *USA Today*.

A Requiem Mass began at 1 p.m. on New Year's Eve at Nativity of the Blessed Virgin Mary Church downtown on Howard Avenue. Although this was the holiday season, there wasn't enough room in Biloxi's largest Catholic Church to accommodate those wanting to say a final farewell to Mary. Some stood at the back of the church, while others waited outside. The Nativity BVM Choir sang, and Bishop Howze presided over the solemn ceremonies. He was assisted by Bob's brother, Father Bud, and seven other local priests.

The family asked friends to make a donation, in lieu of flowers, to a Mary Mahoney Scholarship Fund, which was established at Mercy

Cross High School. The church overflowed with flowers anyway. Mary was laid to rest in a family crypt at Southern Memorial Park in the shadows of the Broadwater Hotel, where she spent many joyful times. As she had requested, some of her waiters, clad in their green vests and black pants, served as pallbearers.

The family went into mourning briefly, but there was a business to run and Mary would have wanted "the show to go on."

Eulogies poured into the local newspaper, but one especially stands out. It was written by John Michael O'Keefe, one of the sons of Mary's dear friends, Jerry and Annette O'Keefe.

> "There never were patrons or clients eating at Mary Mahoney's," wrote O'Keefe. "There were only friends. New friends and old friends. A meal was an introduction to Mary, and a spirited conversation about your life and her life. Of course, she wanted to know if the food was good; but more than that, she wanted to know about you.

> "How many untold thousands have been touched by her love? How many have been helped? It is no accident that when someone joined her work force, they found a home . . . As I sit now, halfway around the world, and look at the time-worn cities and proud people of her native Yugoslavia, I get a little more sense of her. In Dubrovnik, the sun falls into the Adriatic Sea, and the fishermen come home with their catch. There is no gentle beach to greet them, but stone-faced cliffs and mountains out of which they carved their homes. Their faces are weather-lined, much like the faces of their cousins in Biloxi. And the sparkle of the eyes is there.

> "It is no wonder that Mary choose Biloxi as her home. The gentle sea, the fresh seafood, and another proud and strong people were calling. She has left a beautiful legacy of love, and a beautiful family to continue building the service and companionship of the Old French House. However, the spirit of Mary will always be with us, like the gentle Gulf breeze that lifts our hearts. We love you, Mary. Say hello to God for us."

TEN YEARS AFTER Mary's death, she was still making the news. In late 1995, a resolution was passed by the Board of Directors of the Biloxi Chamber of Commerce asking City Council to consider renaming the portion of Magnolia Street in front of the Old French House "Mary Mahoney Way" in honor of Mary's many civic contributions.

The request for the name change drew response, pro and con, from property owners and businessmen when the issue came before the City Planning Commission at a meeting on December 21, 1995. Life-long Biloxi resident, seventy-year-old James Richmond, was among the most vocal in support of the name change. Richmond's opinion was that even if the restaurant did not exist, Mary should be honored for what she accomplished.

"I feel like it would be an honor to have an area within the city named after a person of Mary Mahoney's caliber," said Richmond. "First of all, she was a feminist and entered the man's world—a man's world long before other people came forward and became feminists.

"Another important thing she did, she preserved one of the oldest buildings in the Mississippi Valley and kept it intact, although we had no architect committee at that time, no historical committee. There were no commissions to keep anyone from tearing the building down and doing anything with it. She has preserved one of the largest and oldest oak trees adjacent to the building itself. The preservation that she did, just that, and the fact that she has been the anchor of that particular part of the city of Biloxi, which has mushroomed and is one of the safest retail areas and one of the most sought-after, beautiful areas . . . if she did just that, she deserves to have a street named after her.

"The time has come that we start naming things within the city . . . for historical people, people who've had some effect on our community, people who have saved the history of the community and saved the life of the things we have . . . This could be the beginning of establishing streets to be named after people, solid citizens, people . . . who did their civic duties. And Mary actually was a civic person. She participated in everything. She was not afraid of controversy. She was not afraid of losing her business or her business being taken away from her, because if there was something she was in favor of, she fought for it and spoke out . . . As one who was raised here, went to school here, knew Mary personally, knew how hard she worked and how hard she strived and what she has done, I think it's only befitting that the change be made in her favor and the street be named for her."

Bobby spoke on his mother's behalf. He recounted her rise from being the daughter of an immigrant fisherman, to her apprenticeship at the Tivoli Lounge, then her founding of the Old French House

Restaurant. He pointed out that Mary was selected Mississippi's Small Business Person of the Year in 1982. Her restaurant was among the few chosen to serve President Ronald Reagan on the White House lawn in 1984. After having been named the first woman president of the Biloxi Chamber of Commerce, she appointed the first African-American to the Chamber's Board of Directors. "To the end, Mother was always an ambassador to the state and to the city and she loved both of them dearly," said Mahoney. "And I think it would be a fitting honor that Magnolia Mall or Rue Magnolia be named after her."

Edmond Boudreaux, president of the Mississippi Coast Historical and Genealogical Society and president of the Mississippi Archeological Association, opposed the name change, as did Buddy Fountain, who owned the Fountain Restaurant and Fountain Square across from the Old French House. The name change was defeated by a 4-1 vote, but a large meeting room in the Chamber of Commerce Building was later named in Mary's honor.

MORE THAN TWELVE YEARS have passed since Mary's death, and the restaurant and her family thrive, never forgetting the legacy she left behind. Besides her mother, five of Mary's dear friends have passed while this book was being written: They are Glen Cothern, Hilda Covacevich Hoover Smith, Vernon Pringle, Vivian Hirsch, and Annette O'Keefe.

The Old French House has maintained its prominence among gourmet restaurants. It continues to be written about in the nation's newspapers and magazines, and is consistently ranked among the most popular restaurant of travelers on Tauk tours.

The locals still come too, like Pascagoula oilman Alf Dantzler. His family has a reserved table and comes to eat at the restaurant every Saturday night when they're in town. It's a tradition Dantzler has practiced for the last thirty years.

Celebrities still frequent the place. Most recently, Mississippi author and lawyer John Grisham came to dine while he and movie firm executives scouted out Biloxi as the location for the filming of his best-selling book, "Runaway Jury." Grisham mentions the Old French House Restaurant three times in his book. Barbara Eden of "I Dream of Jeannie" fame came to open the Palace Casino in Biloxi two years

ago, and "just had to come to the Old French House to dine." Other celebrities who have dined there include: newsman Harry Reasoner; singers Randy Travis, Robert Merrill, and Diana Ross; actors Paul Newman and Joanne Woodward, Natalie Wood, Charles Bronson, Denzel Washington; Adam West of "Batman" fame, Jon Provost (Timmie on "Lassie"); television game show host Bob Barker; David Frost and model Karen Graham; author Wyatt Cooper, husband of Gloria Vanderbilt; bandleader Mitch Miller; playwright Tennessee Williams; John Mecom, former owner of the New Orleans Saints football team, and former Saints quarterback Archie Manning, legendary Alabama Coach Paul "Bear" Bryant; ballet stars Mikhail Baryshnikov, Peter Martens, and Edward Valella.

Mary's mother remained loved and protected, living with Bob until she died in 1987 at almost ninety years of age.

Bob still lives on the premises and is in the restaurant every day. He's devoted to his five grandchildren and carts grandson Josh back and forth to school each day. He also visits his brother, Father Bud, on a regular basis. Father Bud, who is in his eighties, lives at Notre Dame University in South Bend, Indiana.

Bobby now serves as President of the Old French House, and has taken over the role of chief greeter of guests and friends who come to dine. He admits, at first, he wasn't really comfortable being thrust into the limelight, but over the years, he had developed a repertoire he uses to put guests at ease. "I have what I call my standard 'church jokes,'" Bobby explains. A few samples:

> There were these two guys who loved to play baseball. They didn't miss a day. They bumped into each other at church one day, and one guy said, "I don't think I want to go to heaven if they don't play baseball up there." They made a pact, and promised if one died before the other, he would try and make contact with the survivor on earth to let him know if, indeed, they did play baseball in heaven. One guy died, and he did make contact with his surviving friend. He told his buddy, he had some good news and some bad news. "What's the good news?" his friend asked. "They have some great baseball leagues up here. They play everyday." "That's great," his friend said. "What's the bad news?" "You're pitching tomorrow," his friend replied.

Another: "What do you call a dog with no legs? It doesn't matter, he won't come anyway."

In another story, Bobby tells about a son who asked his father for a new automobile, and his father said he would buy him one if he read the Bible every day and cut his long hair. The boy diligently read his Bible every day, but his father noticed he didn't get his hair cut, and he asked his son why. The son replied, "Jesus had long hair." The father replied, "Yes, and he walked everywhere, too."

Bobby was in the forefront of the move to legalize waterfront gambling in Mississippi. He also remains active in community and tourist organizations, and recently completed an eight-year term on the Board of Directors of the Mississippi Coast Coliseum and Convention Center. He says his mother would have been in the midst of the casino action.

The talk about gambling brings one of Bobby's favorite stories to mind. "Mother loved to gamble, and she spent many nights and quite a lot of money at the (illegal) casino upstairs at one of the hotels on the beach," Bobby recalled. "I was working at the restaurant, making about $2.50 an hour, when I told her I got an offer to deal craps at the casino and make a helluva lot more money, but I was worried what her friends would think when they found out I was working there. Mother told me, 'Go ahead and take the job. Hell, I'll tell them you're a croupier. They won't know what that is.'"

Bobby and his wife, the former Sandra Newman, now have three children. Daughter Stacy attends Gulf Coast Community College, but works in the restaurant, along with sister, Caty, who recently graduated from the University of Southern Mississippi. Son Trae (Robert Mahoney III) attends Jefferson Davis Community College and works for a Biloxi radio station.

Mary's daughter Eileen is divorced now, and like Bobby, is in the restaurant every day. Eileen's daughter, Nicole, born in 1982, is now a teenager, and son Josh is fourteen.

Andrew's first wife, Mary Parker, died in 1988. They raised four children, now all in their twenties. Margaret works for a CPA firm in San Francisco. Andrea is in marketing with one of the local casinos. Joanna is a dietician with Gulfport Memorial Hospital. Son Tony, (named for his great-grandfather) is a local building contractor. Mary's

brother Andrew married Sarah Gautreaux in 1991. Sarah helps with clerical work at the restaurant. Mary's sister, Annie, and her husband, Roy, traded their catamaran in years ago and put down roots, building a house on the Dog River in Mobile in 1981. They have five children and thirteen grandchildren, and still remain close to the family in Biloxi. Every time she returns to the Old French House, Annie says, "It makes me feel proud I was her sister."

Friends Remember Mary

Brother Herman E. Zaccarelli

In May 1986, Brother Herman E. Zaccarelli, director of Purdue University's Institute of Restaurant, Hotel and Institutional Management, wrote Bob Mahoney to announce that Purdue would establish a scholarship in the name of Mary Mahoney.

"Mary epitomized everything that is outstanding in the hospitality-restaurant industry," Zaccarelli wrote. "She had an effervescent personality to greet her guests; she was most sensitive to her staff and had a rapport that is the very envy of other restaurateurs in the industry . . . She was, above all, a leader with a great creativity and gave inspiration to her colleagues . . . This scholarship . . . established in her memory . . . will perpetuate among a younger generation of students her greatness in our history."

A plaque denoting the Institute's esteem of Mary Mahoney is displayed in a prominent place in the Old French House Restaurant, and Brother Zaccarelli delivered it personally in July 1986.

Jerry Stafford

Jerry Stafford, Mary's close friend and confidant throughout her life, remembers Mary always liked to make a grand entrance. It's a trait Mary carried over to her restaurant, where she would dress each night to meet and greet her guests.

"I remember the first night I met her," Jerry recalls. "She was Cleopatra [in 1955] and the Queen of the young Matrons Carnival Ball. The curtains on stage were closed before her entrance, and Mary was completely hidden. The music began, then the drapes parted. A group of slaves carried Mary out on a litter to greet her cheering

subjects. The crowd went absolutely wild, especially when they re-
alized it was Mary."

Jerry and Mary became fast friends and Mary asked her to mind
Bobby at nights while she tended the bar at the Tivoli. "She had no
secrets from me, and I had no secrets from her," Jerry said.

Mary introduced Jerry to grand opera. "She invited me to go and
see "La Boheme" in New Orleans, and I told her I didn't think I
would like opera. But I loved it. And we went back for others." Jerry
said after the opera, "Mary and I would roam Bourbon Street until
sometimes three in the morning, and nobody ever bothered us."
They'd travel to New Orleans by train and stay overnight at the
Roosevelt Hotel.

Jerry was secretary to City Commissioners Pete Elder and Dominic
Fallo, then to Mayor Laz Quave (1950 - 1955), and she would come
to Mary's bar at the Tivoli Hotel for afternoon cocktails and lively
conversation. "I think she'd open around 10 a.m. and close at 2 a.m.
or whenever, but it was packed all the time. And there were all kinds
of people there—sometimes state and local politicians, always trav-
eling salesmen, the locals who worked at Keesler and city hall—
always a good mix of people. Of course, Mary always dreamed of
new party schemes or something to keep her crowd. Sometimes she'd
ask us to bring a covered dish."

"I remember one time we were listening to the old 'Hit Parade' on
the radio, and someone was singing 'Autumn Leaves,' and Mary said
it was being sung all wrong. So one of the bar patrons let us use his
phone credit card and Mary called CBS Radio and told them it was
being sung wrong, and the next time we heard it, it was sung right."

Jerry lived just a few blocks away from Mary, on Howard Avenue,
and Bobby would stay with her until Mary picked him up at night.
Bobby had plenty of company. Jerry was raising three kids at home,
and they were all pretty close in age. As compensation, Mary would
always treat Jerry to bingo at St. Michael's on Friday nights. For
relaxation, Jerry and Mary would also often sneak away to take in a
movie. "She was a pretty bad driver," Jerry recalled. "One time we
were headed to see a Frank Sinatra movie, and she plowed into the
back of a car on the beach. I think Dr. Wally Sekul came to the scene.
Mary fainted when she saw the lady she piled into was bleeding. I

busted my mouth. Luckily, none of our injuries were serious."

Over the years, the friendship grew. "I was a sponsor when Mary's mother became a U. S. citizen," Jerry recalled. "That was a wonderful day for the whole family."

She remembers Mary's determination well. "We used to all puff one cigarette after another at the bar. And one Lent, Mary announced she was going to give up smoking. And she never went back."

Jerry said she and Mary were competitors for one dubious prize. "I remember going up to her bedroom, and there were beads and earrings and all kinds of stuff cluttering up the top of the dresser, and the closets were always bulging at the seams. And there were boxes stuffed under the bed. I told her if there was a contest for the worst housekeeper, she and I would be in a tie. Mary believed in old things. That's where she got most of her clothes—from the Salvation Army and places like that. And they looked terrific on her."

Jerry was there opening night when Mary launched the Old French House venture. "I was helping her hang the drapes that sister Annie had made, and Mary was a nervous wreck," Jerry recalled. "I told her, anything you have something to do with will be a success. And she never looked back. I always said, when they made Mary, they threw away the pattern."

Jan (Skelton) Schwarz

Jan (Skelton) Schwarz was divorced and raising a four-year-old son, Richard, in Philadelphia, Pennsylvania, when she decided to settle in Biloxi. She had come to visit friends and liked the weather and the town. She found a job with the Locator's Office at Keesler Air Force Base, and Mary went to work there shortly afterwards.

At work, Jan and Mary formed a friendship that would last over forty years. They raised babies together, consoled each other in times of personal crisis, and were inseparable. Although Jan eventually left Biloxi and took up permanent residence in Washington, D.C., she and Mary always kept in touch. "She still exists to me, although I can't see or speak to her. Nobody as vibrant as Mary can be in the past," says Jan.

Mary's sole mate and friend of 40 years, Jan Schwarz.

Jan still blames Mary "for urging me to marry the nerd" (an Air Force Officer who will remain nameless). "But because of that catastrophe, our friendship was sealed," she said. She got to be good friends with Mary's parents as well, often invited to the family's home for dinner and to special occasions like Mary's wedding. "I still remember Mary's beautiful wedding and the innocence she brought to it, and Uncle Tony's gesture (sort of pushing Mary away after he raised up her veil and kissed her) before the vows were sealed in concrete."

Jan and Mary were pregnant together, and Jan brought her second son, Michael, into the world in May 1946, three months before Mary's first son Bobby was born. Shortly afterwards, Jan put her sons in the care of the good sisters at St. Michael's nursery and left for Philadelphia to stay a month at the side of her dying father. He died two days after her return to Biloxi. Bob and Mary made the return trip back to Philadelphia with Jan for the funeral and services. "Bob's brother, Father Bud, was stationed at a parish in the Philadelphia suburbs, and after the services, they brought him over to the house one evening. He recited the rosary. Not being a Catholic, I think that's what it

was, but it was consoling and their strength helped me through that tough time," she recalls.

The three friends returned to Biloxi, and Jan remembers a very pregnant Mary battling a house full of roaches in Jan's Harrison Court apartment. "I was, and to this day am, terrified of roaches, so I set off a killer bomb and I went to the beach for the day. That night, Mary came to my rescue. I think every roach within a mile radius descended on that apartment," said Jan. "I can still see her. There she was, pregnant as all hell, climbing on chairs and whatever, catching those ugly monsters while I screamed." A few days later, Bobby came into the world. "He was some big boy, and was as darling then as he is now," Jan says.

Jan's relatively new marriage was already in trouble. Her husband was sent for a year's tour of duty in the Philippines. She stayed with the boys in Biloxi. "For a year, my life was my own, but Mary and Bob were my overseers," she said. Maybe they were too protective. Jan remembers Mary and Bob taking her to a Mardi Gras dance on the beach, then dropping her back off at her apartment after an early morning breakfast. "Mary and Bob noticed a taxi loitering in the area after they dropped me off. A handsome Navy officer had followed us from the beach, and Mary and Bob played hide and seek with the taxi, until he finally gave up. Damn!"

Jan was in Biloxi when the 1947 Hurricane hit, knocking out many railroad bridges throughout the South. She had planned to take her sons on a train trip through the West before they departed to meet her husband in Manila. "Mary and Bob came to my rescue again. They managed to get us tickets that rerouted us through St. Louis." She says going to Manila "was another big mistake," but she managed to stay for a year. When Jan returned with her husband and family to the Harrison Court apartment, Mary and Bob had moved into the family home on Howard Avenue. Mary's parents took up residence in an apartment behind the grocery store Tony had opened on Bay View.

Jan would "escape" her deteriorating situation at home and come over to Mary's once a week to do laundry and help watch Bobby. She'd pick up Bob's jackets that were always draped over the dining room chairs, and clean up the other clutter around the house. "I still

think of Bobby getting his own cornflakes and eating them with water because he couldn't reach the milk. And another time, when he put a goldfish in the frying pan, but it escaped."

Some days she'd go over to Bay View and sit with Mary while she worked in her family's store. "That's when I was on my Barq's Root Beer binge. If Mary wouldn't deliver them, I'd be on the Bay drinking them. I'd bring Michael over, and he and Bobby would stand on chairs and play the slot machines for hours," Jan remembers.

Jan filed for divorce, then after it was granted, moved out of the house on Harrison Court. The day her divorce was final, she and her sons came to stay with Mary and Bob until Jan's brother arrived to take them to live in Washington, D.C. To keep the boys occupied, Jan bought a movie projector and showed the boys some cartoons. But the adults decided to look at the movies of Mary's wedding, as the boys "suffered through the whole thing." "The good part came afterwards. One of the boys pressed the rewind, and everything ran backwards. They loved it."

Jan and the boys made the move to D.C., and Jan found a job. "I missed Mary so much, but she never lost touch." Jan never took vacations, saving the money she made to send her boys to summer camp. "One year when the boys were at camp, Mary and Bob sent me a plane ticket to Biloxi. That's when Mary had her bar at the Tivoli Hotel. It was just like old times being with Mary again."

Jan was a 'neat freak;" Mary was not. She spent the days cleaning up Mary's house and "tossing out half of the hundreds of *New York Times* that Mary had stashed around the place." "I still remember Mary's closets chock full of evening gowns, suits, dresses and shoes and pantyhose by the hundreds. How many times did I put them in filing order—by color and seasons—and tried to bring some order to her dresser drawers?" At night she'd go down to the bar. Mary knew a lot of "eligible people" and Jan remembers once she fixed her and Hilda Covacevich up with blind dates. "It was a wonderful vacation—at least for me. Hilda struck out."

Jan visited another time after Mary was forced to give up her bar at the Tivoli Hotel, and Mary had her regular customers now coming over to her house on the beach to drink and talk in the afternoons. "Damn! That was fun. I never was much of a bar person, but I en-

joyed it when Mr. Elmer (Williams) and some of the others would come over at 'tea time.' The breakfast room was serving as the 'Tea Room.' Jan next came to visit Mary in 1956 shortly after Eileen was born. "She was beautiful, a doll to dress," she remembers.

Mary called Jan to tell her the news that she and Bob found an old house on Magnolia Street and planned to turn it into a fine sit-down restaurant. "I thought how the hell is that going to work out, since cooking wasn't on her 'love to do' list. But I knew if Mary wanted it, nothing would stop her." Of course, Jan came for the grand opening.

It wasn't long after the restaurant was opened and enjoying success that Jan faced another crisis. Son Richard was attending Southern Mississippi in Hattiesburg, and Jan was telephoned at 4 a.m. and told he was rescued, but hurt when the Kappa Sigma fraternity house burned to the ground. "It wasn't long afterwards that Mary called, having heard the news on the "Today" show. When I finally caught a plane to Hattiesburg the next day, Mary and Bob were there with money, as always." Jan stayed by her son's bedside in the hospital, and only when she was sure he was out of danger did she go on to Biloxi to stay with Mary and Bob for a few days.

Jan remembers the good times, too, when a hotel on the beach ran an illegal casino upstairs for only an elite clientele. "I laugh every time I remember the glasses of scotch spilling all over the table. Mary would wave her hand, urging the wheel on, and knock down anything that was nearby."

Jan stayed with Mary when Mary's father died. "We stayed with him until the end, and I worried about her reaction, but she was like a rock. It stunned us, as her world revolved around her 'Tony.' I was glad I was with her because she had always been everywhere for me, and I could do so little in return—except love her more than any other person on earth."

Once Mary brought Eileen (as a toddler) to visit Jan and her family in D.C. enroute to visit in-laws in Williamsport, Pennsylvania. "I still have the huge poster with Eileen, Rich, and Michael," Jan says. The next time Mary brought Eileen she was "a very young lady," Jan recalled. "Bob shoved Mary and Eileen on a plane out of town when dispensing hard liquor was temporarily banned. State officials closed down the bars until local counties approved or rejected the sale of

hard liquor. "We went to New York for a couple of days," Jan said, For the first time, she could act as hostess. "I had a friend in the hotel business, and he arranged reservations gratis. We went to a night club and Eileen wasn't too keen on that. We asked the cab driver if he thought the show would be okay for a pre-teen. He said it would not be if it were his daughter, but it wasn't so bad, and Eileen would turn her head when risque costumes appeared." They posed for a picture in the nightclub. Jan still has it. "Mary looked glamorous, as always," she recalls.

Jan returned to Biloxi when Mary thought it was time to redo the attic at the house on the beach and turn it into Eileen's personal room. "It was such a joy creating Eileen's upstairs quarters," said Jan. "We used yards and yards of fabric, and I still think it should have appeared in a magazine as a 'low-budget' makeover." Jan also helped Mary find the chandelier for the living room, and covered two bathroom windows with Mary's jewelry hung from hooks.

Jan wasn't in Biloxi when Camille hit in 1969, but caught a plane to Biloxi as soon as the National Guard allowed people to enter the area. "It still breaks my heart when I look at the pictures of the house after Camille did her thing—the chandelier askew . . . the floors dipping into the basement . . . all of the personal losses . . . and Eileen's suite—gone. But the little guest house in the back merely moved off its foundations, and not one thing was broken . . . glasses were still standing on the shelves intact." Jan pitched in to help salvage what could be salvaged, but she seized the opportunity to throw away some clutter, too. "I filled the trash chute that ran from ground level to Mary's room upstairs with hundreds of *New York Times* that Mary had managed to salvage after the storm. I would ask Francine [the maid] to bring me more to throw out. She'd always say, 'I can't. Miss Mary would be upset.' I told her Mary would never know the difference."

Later Jan was visiting when Andrew and others began laying out plans to build the family apartments behind the third addition to the Old French House complex. "I really bugged them. God! They hated to see me coming. I was always saying, 'No, the wall sconces should be lower,' then I'd put a lipstick X where they should be—not up by the ceiling." When she returned to D.C., Jan wrote Mary letters point-

ing out that the French doors in the apartment should be tall, not standard. "The contractors didn't listen, but it was exciting seeing the apartment take shape," she recalled.

Mary was always pressuring her to come and live in Biloxi again. "Even after I was finding one excuse after another to return to Washington, I still think of Biloxi as my home and the Mahoneys as my family," said Jan, who still resides in Washington.

When Mary began catering an annual luncheon for the Mississippi legislative delegation, she made yearly trips to D.C., and Jan relished her visits. "It was wonderful. She always stayed a few extra days to go shopping, of course.

On another visit to D.C., Jan and Mary went out to dinner with friends and stopped afterwards at a restaurant bar for a nightcap. "There was a man playing the piano and singing, and Mary went over to say hello and told him she enjoyed his music very much. Then we went home," said Jan. "A year later when Mary and Bob were in town for the Small Business Person of the Year Award [which Mary was presented at the White House as the Mississippi recipient in 1982], we went to another restaurant downtown. A man was playing the piano and singing. Mary had wandered off somewhere, but when she came back, the man came to our table and said, 'Aren't you Mary Mahoney from Mississippi?' "Mary said yes, and Bob said, 'I'll bet you remember her by those glasses she wears [the butterfly ones].' The musician said, 'No, I'm blind. But I remember her voice from a year or so ago when I was playing in another place.' He gave her a cassette of his songs."

Jan accompanied Mary on a buying trip to Merida, Mexico, in November 1979, the day the Americans were taken hostage in Iran. "We went to Merida for the shirts and dresses for Mary's shop and had dinner with this lady who had shops all over Mexico and designed the dresses and dolls that Mary carried in her shop," Jan remembers. "Then we flew to Cancun for a few days. We took a day trip to some of the ruins. My damned camera jammed and couldn't be fixed. Mary had Bob's and she was standing on the pyramid stairs so I could take her picture. I asked her how the camera worked, and she said when the X shows that's when you aim and fire. So I did. When we arrived back in Biloxi, and Mary and Bob were driving me

Bob and Mary are shown dining in New York's Rainbow Room with Bob's brother, Father Charles (Bud) Mahoney in October, 1977.

to Mobile to catch my plane to D.C., I told Bob to be sure and send me the pictures. Some way or the other the conversation turned to the camera and I mentioned the X—He said, 'You stupid jerks. That's when the shutter is closed.'"

Mary and Bob also flew to D.C. for the Pope's visit on the White House lawn—invitation only. "We went to my favorite French restaurant in town. Had the best table and stayed until almost everyone had left, except for a table of young people. For once I was able to pick up the check. And that was a feat whenever Mary and Bob were around," Jan recalled. Sunday was the big day for the Pope's visit, and Mary's tickets seated her in front of a group of young people on the White House grounds. "One of the young men tapped her on the shoulder and thanked her for the night before—when they were able to stay late at the restaurant because we stayed at our table," said Jan. "Mary wondered what the hell they were talking about. Turns out, they were the young Kennedy clan, chaperoned by Ethel, and they remembered Mary from the restaurant the night before. I don't think anyone ever forgot Mary once they saw her and certainly not

after they met her," said Jan.

Another time, while visiting New York, Mary and Bob called Jan in D.C. and invited her to join them. "We have a suite," they said. "So my brother-in-law, who lives in New York, picked me up at LaGuardia. Mary and Bob had gone to a Broadway play. We waited at the hotel, and it was late when they got back. We were all starved. We wound up having dinner at Jimmy McMullins, which still exists." Even though they stayed up until the wee hours, Mary was ready to hit the resale shops in New York the next morning, and Jan had to trod along. "She picked up a Bill Blass beaded affair—among other things. We always hit the resale shops in New York and Washington practically every time she came," said Jan. "On Sunday, we met Father Bud at St. Patrick's Cathedral, and he said a private Mass for us. Then he gave us a tour of the priests' quarters, and we had lunch at the Rainbow Room. What a wonderful memory."

Once Mary and Jan went to New Orleans for opening night of the opera. "With all of Mary's clothes, she had grabbed a chiffon number. When she tried it on, the damned thing was dated—too long. We called downstairs at the hotel and one of the maids had a needle and some red thread. Mary stood impatiently with a glass of scotch in her hand while I sat on the floor attempting to hem the dress. It was a full skirt, so she stood—legs apart—while I made a feeble attempt to remedy the situation. And I screw up trying to sew a button on something." The job was done, and Mary and Jan ran off to dinner, then the opera. "At intermission, it seemed everyone at the opera knew Mary," said Jan. "The next day the New Orleans paper mentioned the celebs at opening night and said, 'Of course, the always fashionable Mary Mahoney looked stunning, as usual.' We laughed ourselves sick over that since the hem of the dress was so uneven— but then Mary made everything she wore look fabulous."

Jan remembers Mary remained loyal to her close circle of friends even though individual relations were sometime strained. "Mary told me that for some reason, Holmes [Love] and Marion [Williams] were annoyed with her, and had constructed a black curtain over a picture they had of her in the kitchen. They closed the curtain to display to friends the relationship was estranged. We ran into them at the Saengar Theatre during a show, and Mary said, 'I want to see that damned

curtain.' So after the show, they invited us over, showed Mary how it worked, and she loved it. Of course, they remained close friends for years, and she loved them dearly, as did I. No matter what, Mary's sense of humor prevailed."

Mary was always the optimist as was proved by her lack of concern when she called Jan in Washington to tell her she was walking crooked and planned to consult with her doctor. "Then, there was no fear in her voice when she called from the hospital the night before her initial surgery, and she made light of her impending surgery," said Jan. "Hello Dawlin. Guess what? I actually have a brain," Mary joked. Jan later found the letter Mary wrote to her family in the event the surgery didn't go as planned.

Jan would make several trips down to Biloxi as Mary's condition gradually went from bad to worse. "The most horrible thing was to witness the stages of deterioration," she said. "I went with Mary and Hazel Pitalo to New Orleans for an appointment with Mary's doctor. It was then I learned that there was no hope. Mary never told me. We made her buy a red fringed dress before we left town. She seemed disinterested—that was not her persona. Stupid me. I felt that if she bought a dress all the rest would go away." Jan and Mary's sister, Annie, called prominent doctors all over Texas trying to find one who might be able to save Mary. "We struck out and the world is sadder for our loss," said Jan.

Jan spent more than a few days and nights with Mary putting pictures in albums, going through boxes and boxes of papers and letters that Mary told her to save. "One was from me, and I told her she didn't need that—it was just my notes when they were building the apartments. She said, 'Save it.'" The sorting and labeling and organizing went on for days. "Mary was very quiet, and I wanted to talk to her about her illness, but I couldn't bring up the topic. Mary was putting her life in order and nothing was going to stop her."

With the Sunday Mary Mahoney Appreciation Day arriving, Jan took Mary to shop for a new dress and a new wig. There was a wedding scheduled outdoors on the patio the Saturday before, but Jan and sister Annie suggested that Mary save her energies for the big Sunday ahead. "Sunday arrived and Mary seemed like her usual self," said Jan. "We went down the back stairs and into the Herald Room,

which was packed with people. Mary talked to everyone. It was miraculous to see Mary like her old self. When the time came for the honors and the TV cameras started rolling, Mary spoke and thanked everyone. I rushed into another room so she couldn't see me crying. To see Mary going through all this as though it was just another day was heartbreaking."

The next day, Jan was upstairs in the apartment with Mary trying to decide what she might like for lunch, and Mary finally decided on the fish. One of the girls from the restaurant brought the food up to the apartment, and Jan went into the kitchen to get Mary some milk. "Within thirty seconds, Mary had a seizure. I screamed for anyone to come up. It was so horrible. Finally, the ambulance arrived and they took Mary down the spiral stairs leading to the courtyard, then to the hospital," Jan remembered. "I stayed by her bed all night begging Mary to wake up. Her feet and legs were so cold. The next day, a helicopter arrived and airlifted Mary to Ochsner Hospital in New Orleans." Jan accompanied Bob to New Orleans the following day, and they stayed at the hotel attached to the clinic until they were allowed to see Mary. They were with her when the doctors gathered around to see if Mary knew where she was or who she was. Her speech and mobility were impaired by the seizure, and after some rest, the doctors decided to let her go back home to Biloxi. "That's when the awful stages began," said Jan. "There was little talk—just a kind of parrot reaction. Eating was difficult. Ice cream seemed to soothe her." Mary couldn't stand alone, so Jan would get into the shower with her. "We would both laugh as we slipped to the floor." The wheelchair was no longer an option. Annie and Jan had hoped they could at least take her out on the balcony, but she could barely sit up.

Jan had to return to D.C., but interviewed a couple of women to care for Mary and see that she received her medicine. "I told her I'd be back again, took a shuttle to New Orleans, then flew home, but I couldn't stay away, so I turned around and went back to Biloxi again arriving around 11:30 p.m." Jan dashed up to Mary's room. "I knelt by Mary and told her I had come back to bug her. She stared with her eyes—so large, and then took my face in her hands, and said, 'Jan.' It broke my heart. That was the last time I heard her voice," said Jan.

Mary had another seizure shortly afterwards, and returned to Biloxi Hospital. Jan spent nights with her for two or three weeks. Bobby went by every single night after the restaurant closed. "I talked to her constantly, hoping she could hear me. One never knows when a coma shuts out everything." Eileen took Jan to the hospital for what turned out to be a final farewell before she had to return to Washington again. "When Bobby called to tell me Mary had passed, it was one of the darkest days of my life," said Jan.

Jan still has the little pin Mary gave her that's engraved, with her favorite expression: "Aw! Shit!"

And pictures of Mary are everywhere in Jan's apartment. Since Mary's death, Jan has also suffered the loss of a brother and a sister-in-law. "Although I loved them, the loss can't compare to the loss of Mary," admits Jan. "I loved her so very much and still do. She was the most beautiful person on earth—she gave to everyone. Her heart was so filled with love and she embraced every person she met with that love. I was blessed having her in my life. "Sometimes when the phone rings, I forget, and expect to hear her voice saying, 'Hi, Dawhling!'"

Jerry O'Keefe

Jerry O'Keefe grew up in Biloxi. His brother, John, attended Sacred Heart with Mary, and dated her a few times. "We kidded her a lot when she announced her engagement to Bob Mahoney," said Jerry. "We said her daddy had to pay Father Mullin to go out and find her a husband."

O'Keefe went off to law school, Tulane University, New Orleans, and returned to Biloxi with his young bride, Annette, in 1948. The O'Keefes made their home on Fayard Street.

When Mary opened her bar at the Tivoli Hotel, Jerry became a regular customer. He was working for his family's funeral home and insurance business, thinking about going into politics. "I was pretty much a daily customer," said O'Keefe. "Of course, Elmer Williams was a fixture down there, and J. J. "Specs" Peretich, Pete Elder, and Vernon Pringle always hung out there, too. "Mary would usually open up the place around 10:30 or 11 o'clock and have the first drink

From left, Mississippi Governor Bill Waller and wife, with Jerry and Annette O'Keefe and Mary Mahoney.

with Elmer. She'd leave and take a little nap, then come back for cocktail hour and drink along with the rest of us until the bar closed. Elmer used to kid her about drinking bar gin, and having customers pay for call brand. He'd say, the more she drank, the more she saved. The bar was a hot bed of political intrigue, O'Keefe said. "Anybody who had any aspirations for public office got to know Mary, and if she supported you, you couldn't have a more loyal friend."

Mary and Annette O'Keefe became close friends, too. They formed the Young Matrons Carnival Club together. And Mary's daughter, Eileen, would spend many nights with the growing O'Keefe clan of thirteen children. "Mary was one of my staunchest supporters and campaign workers when I ran for the state legislature in 1968," said O'Keefe. "The night I was elected was the first night we had slept in the new house on the beach, so we gathered at the new house and listened to the results coming in over the radio. I'd be ahead, and we'd open a bottle of champagne. Then I'd get behind, and we'd warm up a pot of coffee. That went on all night long 'til the early

morning hours, until we realized we were successful.

"Next fall we were all big supporters of John F. Kennedy, and Annette and I, we were all down at the bar having an election night party. Eileen stayed at our house with my daughter Kileen and the other children. Annette and I finally left the bar and went home and went to bed about three o'clock in the morning. Some of the children were awake and some of them were asleep. They woke everybody up about 5 a.m. screaming and yelling that Kennedy had been elected president." Of course, the O'Keefes and the Mahoneys went to Washington for the inauguration.

After the Old French House opened, the O'Keefes would become regular customers, and hosted business and political friends at the restaurant. Bob Mahoney served as chairman of Biloxi's Development Commission for several years, and Annette and Mary got involved in a lot of Chamber of Commerce membership and fundraising drives. "Mary had a great spirit," said O'Keefe. "She had indefatigable energy and determination to do things. She was a great entrepreneur and had a lot of civic interest. Bob gave her complete leeway in running that restaurant, but he supported her in every way he could."

O'Keefe said Hurricane Camille presented Mary even more of an opportunity, since the Old French House and the Buena Vista were the only two restaurants that reopened almost right away. "Of course by that time, the restaurant had already gained national recognition. But I think even if her restaurant would have been destroyed, Mary would have bounced back. She wasn't easily defeated once she made up her mind what she wanted to do," said O'Keefe.

O'Keefe would serve two consecutive terms as mayor of Biloxi, from 1973 to 1981. "One time when I was mayor, Mary accompanied Annette and me to Jackson to visit Gov. Bill Waller. She just charmed him. She asked him to come to Biloxi and ride in the Mardi Gras parade, and he did," said O'Keefe.

Mary always defended the sometimes besieged mayor. "If a certain group in the community was mad at me for something I had done or didn't do, they had better not mention it to Mary. She was my staunchest supporter, next to my wife," he said. Mary also helped Jerry (Jody) O'Keefe, Jr., when he ran for the state legislature, serving from 1968 to 1976.

The O'Keefes traveled with the Mahoneys extensively, including a Chamber of Commerce trip to London, an Amtrak adventure Mary arranged to San Francisco, and to New York. "She was always fun to travel with and be around, but I gave her a bad time on one particular trip," O'Keefe confessed. "Ingalls had a contract to build a fleet of landing assault ships, and there were several Marine Corps officers stationed on the Gulf Coast who were overseeing their construction. Mary told this Lieutenant Colonel in charge of the whole thing that I had been in the Marine Corps, and we later met, and he invited the Mahoneys and the O'Keefes on the ship's last trial run before the ship would be turned over to the base at San Diego. The ship left out of Ingalls, but we flew down to Panama and boarded it on the Gulf [of Mexico] side. We had a great time aboard, but Mary had some anxious moments. I kidded her that no alcohol was allowed on board. When the cocktail hour approached, I could see she was getting a bit agitated, so I told her the captain had invited us to the officer's quarters. And we had our cocktails."

O'Keefe said he didn't know of Mary's illness until she entered Ochsner for her first operation. "I called her and talked with her in the hospital," he said. "Through it all, she never did relinquish her spirit—her zest for life."

O'Keefe's still active in his business interests, but he goes to the restaurant "at least once a week." "Not as much as I used to, since I quit drinking about ten and a half years ago," he said.

He says he feels Mary's presence, through her portraits and mementos that grace the walls. "Bobby has done a wonderful job taking charge of the place, and Eileen's developing more of her mother's personality every day. I still think of them all as my extended family." said O'Keefe.

Annette O'Keefe

Annette O'Keefe's friendship with Mary began in the social atmosphere of founding the Young Matron's Carnival Club in the 1950s, but over the years, the O'Keefe and Mahoney families formed a bond that endures until this day. Mary's daughter Eileen would often spend

Mary poses with devoted friends Jerry and Annette O'Keefe.

nights with the large O'Keefe family when Mary ran the lounge at the Tivoli Hotel.

The O'Keefe's originally lived in a home on Fayard Street, but built a larger one on the beach just east of the Mahoney compound. They moved into their new home the night Jerry was elected to the state legislature. "Of course, Mary was in the midst of all the campaign activities," Annette remembers. "She loved politics, and especially John F. Kennedy. She was a staunch supporter of anyone she admired, and contributed to my husband's campaign and later to my son Jody's campaign when he ran for the state legislature."

"There was no timidity about presenting herself. When we went to Washington for the Kennedy inauguration, she had no hesitation saying who she was and where she was from."

Annette remembers that Mary always loved to belt out the song, "Everything is Beautiful" at the top of her lungs. "And it was truly Mary's philosophy," she said. "Mary always saw the good side of a person. She always saw the good side of a situation, and she was a supreme optimist—an indomitable enthusiast. She was a "yes" person, and rarely said no to any worthwhile idea."

Mary Mahoney and Biloxi Commissioner Pete Elder reigned as Queen and King of LeFemmes Carnival ball in February 1962.

One year, the O'Keefes invited the Mahoneys to celebrate Christmas with them and their large family in Breckenridge, Colorado. "Bob stayed home to mind the restaurant, but Mary and Eileen came. It was a very memorable Christmas. They were part of our family.

"Mary loved music, dramatics, art, and the theatre," Annette recalls. "On one of our trips to New York, Mary left us to run off and see an off-Broadway play called Little Mary Sunshine. The cab driver got lost, and couldn't find the theatre, and Mary later met us at this elegant New York restaurant, and she cried and cried because she had missed the play. Nothing could console her."

Mary and Annette also worked tirelessly for the Biloxi Chamber of Commerce. "Our committee won first place for recruiting the most new members," said Annette. "People only rarely could say no to Mary. We won a trip to Destin, Florida, aboard the "Bank Runner" luxury fishing boat, and our group had a wonderful time catching king mackerel, sunning ourselves by day and partying at night."

Annette has fond memories of Mary reigning over her restaurant clientele. "Mary loved to dress every evening for dinner in her restaurant. She wore fine evening dresses, feather boas, long, large pearls, and unique jewelry. She told me one time that she regarded the restaurant as her own personal stage when she appeared at the dining hour. Mary would stroll from table to table greeting everyone with, 'And, how's everything?' She never overlooked a single person."

Annette frequently accompanied Mary on shopping trips to New Orleans, and her feet start aching when she recalls the incidents. "She was a real killer of a shopper," Annette remembers. "Always a block ahead of me walking. I would give out and have to sit on a curb to rest. She was up one side of Canal Street and down the other. She'd go in a store, try on a dress, buy it, then go on to the next store before I could even decide on anything. And she knew where every thrift shop was in New Orleans—Uptown, Carrollton, or wherever— we'd go to all of them. I was shocked. I never bought used clothes before, but Mary pointed out some of the clothes were never worn, they still had the original designer labels on them. In Manhattan, she was the same way. Her favorite pastime in New York was going to the thrift stores. She was truly a professional shopper."

Towards the end of her life and after several surgeries for the brain

Mary was stunning as Queen of the 1962 LeFemmes Carnival Ball.

tumor, Mary became very reclusive, staying mostly in her apartment above the courtyard complex, and Annette would frequently visit her. "I would go up and bring her Holy Communion. She always had a sweet smile for me and never complained.

"Mary was also one of the most generous persons I ever knew," said Annette. "She always treated the clergy passing through Biloxi to a free meal, and she had an altar full of priests and the Bishop for her funeral mass. Her waiters stood guard at the head and front of her coffin—a most appropriate gesture of love and respect.

"Mary left me a lovely chain and lapis laxuli cross in her will—another mark of her generosity to the ones she loved," said Annette. "I never remember Mary saying an unkind word about a single person. I always felt better for having known Mary, and I will never forget her."

Eddy Alley

Eddy Alley grew up in Biloxi not far from where Mary Mahoney lived, but it wasn't until his adult life that they cultivated a friendship that lasted through her lifetime.

Eddy was in high school and working behind the counter of the Presto Lunch Room at Lameuse and Howard Avenue, when this young Air Force Sergeant began coming in. "Word got around fast then," said Eddy, "and I found out after a few visits his name was Bob Mahoney, and he was dating Mary Cvitanovich. I knew Mary's mother ran a store on Bayview and Main, not far from our house, but I had never actually met Mary. Anyway, Bob would come in the Presto—sometimes before his date with Mary, sometimes afterwards—and he ordered our famous Presto hamburger. They were delicious—pure beef supplied by the Star Grocery owned by Vincent Morice."

When Mary opened her lounge at the Tivoli Hotel, Eddy started going there on a regular basis. "I'd stop in late a night after watching the Tarzan movies. She always had a nice crowd, a fun crowd. I usually met Ronnie [Fountain] there or someone else, and a lot of military [Keesler] people drank there." (Eddy had a clerical job at Keesler). He remembers the parties leading up to Kennedy's election, but says he still could kill himself for missing the night she

Mary and friend Eddy Alley would chat into the wee hours about old movies and movie stars. Eddy always got advance sighting of any celebrities who came into the restaurant.

celebrated Puccini's birthday at her bar.

It wasn't until Mary opened the Old French House that their friendship really blossomed. "We loved old movies and old movie stars, and astrology. I'd stop in practically every night, usually after the 10 o'clock news, and stay for a couple of hours. On weekends, I'd come in and stay and stay. Then we'd go to the Buena Vista for drinks, or we'd go to the Pastime for the breakfast buffet. Ginger (Harwell), A. J. (Swansine), Bob and I usually, but sometimes Buzzy Sekul and a few others would join us.

"I'd read her daily horoscope and come in and tell her about it. I told her she'd make the cover of *Life Magazine* one day, and I'm convinced she would have, if she would have lived long enough. She made a lot of publications, including the *Ford Times.*"

Eddy said he always got advance notice of any celebrity sightings. "Mary or someone would call me, I don't care what time it was, whenever somebody noteworthy would come into the restaurant or bar. Harry Reasoner and his wife came in one year for the Shrimp Blessing, and I went down to meet him. Mary kept the olive that was in his martini glass behind the bar for months. I saw Paul Newman, Joanne Woodward, Charles Bronson, Robert Blake, Diana Ross, and

so many others, I can't remember them all." Eddy said Mary and Bob were in Las Vegas with a group of other friends when Diana Ross came to the Old French House, but Mary knew she was coming and called from Las Vegas to welcome her to the restaurant. "They had a long conversation, and talked about their kids and family, and Mary told Diana she was so sorry she missed her." Eddy met Tennessee Williams at the Old French House, too. "He had his little dog and a couple of friends with him. Bobby called me that night and told me to come down. I offered him a drink, but he declined. He was a very pleasant man—very nice."

A. J. and Eddy sometimes accompanied Mary and Bob to the Saints game at the old Tulane Stadium, and they often went to Mary's house or over to Marion Williams and Holmes Love's house on Sunday afternoon to watch the Saints on television when they played out of town. "They always took us out to eat after the New Orleans games. Mary and Bob were so generous, and they were always so much fun," said Eddy. On another occasion, Eddy said there were two groups in two cars who went to see Carol Channing in "Hello Dolly" in Mobile. "I think June Bru [who lived in Mobile] met us, and Hilda was with us, and A. J.'s mother, Miss Laura. We had a helluva time and we got to meet Carol, of course."

Through the years, Eddy and Mary became close friends, and he rarely saw her in low spirits. "A couple of times when she was down, she says to me, 'Eddy, you're gonna come in here one night, and I'll be long gone on a Greyhound bus,' but that was very seldom," said Eddy. He said Mary loved her restaurant, and she hated closing on Sundays. "That restaurant was her stage," he said. "And she loved playing the part of the grand hostess."

Mary was also a sucker for a sob story, Eddy says. "She'd help out the starving artist, the down-and-out. Mary had money. It was something she could spend. She wasn't interested in money. She loved her clothes, and Mary had some beautiful clothes. She looked good in most of them. She was so colorful, and she loved to dress. She had one dress—a brown satin one—that really didn't suit her, and I told her it wasn't her color, but I don't think that stopped her from wearing it. And she loved people. But she especially loved her family. She was a devoted mother and grandmother."

Eddy said Mary could stay up and drink until late at night and get up after just a few hours sleep. "She was one of those lucky people who required very little sleep. She could drink martinis all night long, and get up the next morning 'bright-eyed and bushy-tailed,' as people say. No hangover or nothing. I used to envy that. Mary was one of the few people who could also cuss, but it really wasn't offensive. She had a little temper, but she'd get mad over something, then get over it. Basically, she was gracious—just loved by everybody."

Eddy was at the Old French House for opening night, but he doesn't remember eating a full meal. He does remember sampling the shrimp cocktails "and having lots of drinks." There were other special times with Mary that Eddy said he will always remember. "Christmas was always special. Mary would send us gumbo or send us flowers at home. She was so generous, so kind-hearted. And New Year's Eve, we'd stay at the bar until four or five in the morning, then we'd all go out for breakfast. That's two times of the year when you're always remembering the past, and what might have been or what could have been, and it was good to have those kind of friends. And her parties on the lawn at her house on the beach were always fun. On her combined birthday and Fourth of July celebration, we'd have drinks on the lawn, and Mary would make her famous potato salad."

Eddy also remembers the parties at the restaurant when Eileen was Queen of Carnival, then Eileen's wedding, and when granddaughter Stacy was also Queen of the Mardi Gras. "No expense was spared," Eddy said. "People are still talking about those parties."

He'd go out with the Mahoneys, too, when they boarded one of the DeJean shrimp boats for the annual Blessing of the Shrimp Fleet. "Mary would go, but I don't think she was too crazy about the water."

Times alone with Mary were special for Eddy, too. "Sometimes late at night, after the dinner crowd had left, we'd sit and talk for hours on end—about almost anything. That's when Mary really had the time to sit and talk and socialize. Sometimes she'd put on her favorite Little Mary Sunshine album, and she'd mime the words. Or sometimes, she'd play an opera she liked or a Broadway show, and it would bring back memories of when she saw this or that or what she was wearing or what happened afterwards. There was always a story behind the music," said Eddy.

Eddy contends Mary could have become Biloxi's first female mayor, if not for her illness, but he admits she never confessed to having that goal. "She knew so many influential people. She loved politics. I think later in life she might have been interested in becoming mayor, and if she ran, she would have won and made a good one. But she was having too good a time running the restaurant."

Eddy said he received an "education" at Mary's. "I learned a lot about music and art and a lot about people. Mary knew about art and she knew about the individual artist. And at Mary's, you met so many people from so many walks of life. And Mary treated everybody equally. I don't think I ever heard Mary talk bad about anybody."

Being a close friend, Eddy heard about Mary's initial signs of illness, but says even after surgery, "She never mentioned anything to me or complained about anything." He remembers bringing Chinese Chews up to Mary when her illness forced her to bed in the upstairs apartment. He said he last saw Mary sitting with Hazel Pitalo in the patio a few days before she went into Biloxi Regional Hospital for the last time. He visited Mary in the hospital and sat with Bob a few days before Mary died, but he doesn't know if Mary knew he was there.

"Before her illness, when we'd laugh and talk at the bar late at night, she'd even talk about what she wanted at the restaurant after she died," Eddy said. "She wanted a statue of herself in the patio with an arm outstretched beckoning people to come inside. And she wanted it carved out of Carara marble—the kind Michelangelo used for his statues. When she heard how expensive the marble was, she said, 'Maybe, I should tuck my arm in to save on marble.' We laughed so many times about that. I can still hear her infectious laughter now, and I'll always remember her and our special times together."

June Bru

June Bru likens her twenty-year friendship with Mary Mahoney to the antics of "Lucy and Ethel." "There was never a dull moment with Mary. She never held back. It was full speed ahead with whatever she did."

It was sheer fate that brought the two together. June was working as a secretary, then office manager for a Cement Company in Mobile, and she would come to Biloxi on weekends to rendezvous with her boyfriend, who drove in from New Orleans. "We usually stayed at the Broadwater," she said. "and we'd eat dinner at the restaurant there on Friday and Saturday nights, but we got a little tired of eating at the same old place, so we asked around about other places to go. And somebody said the Old French House Restaurant had just opened up on East Beach, not too far past the lighthouse, so we went to try the food." Of course, Mary made her way to the table and introduced herself to the couple as soon as they were seated. She sat at their table a long time, learning as much as she could about her two new friends. "Nobody was a stranger to Mary. And before the evening was over, we felt like old friends," June said.

That was the couple's first encounter with Mary, and the two found themselves coming back to the restaurant every time they were in town. "We became fast friends," said June. "Sometimes we wouldn't come in to eat. We'd just sit at the bar, and Mary would steal a moment to have a drink with us. And we'd sit there and wait for her to close. Then she and Bob or just Mary by herself would go out with us and have breakfast at the Pastime Cafe or we'd go to the Marine Room in the Buena Vista Hotel, and drink and talk 'til all hours."

The Mahoneys often invited June and her boyfriend to their home on the beach for the Sunday family dinner. "Mary would start cooking in the kitchen. We might be hung over from the night before, but I'd ask her if she was ready for a martini. She'd say, 'Do you have to ask?'" June recalls.

As time went by, June became attached to the entire family— Mary's mother, the children, Bobby and Eileen, Uncle Niko, Georgo, and all the other relatives. "We'd talk on the phone, sometimes two and three times a week, even though I planned to come down on Friday. If Mary had something to tell you, it couldn't wait," said June. Mary called her one time in a panic, and asked her to take $200 and bail one of her waiters out of the jail in Mobile. "She was having this big party at the restaurant that night, and she said she needed him right away. So I went and got him out. You should have seen the looks when I posted bond for this black man and we walked out together."

June accompanied Mary and daughter Eileen on a whirlwind twenty-one day trip to Europe in 1971. "We flew to England, then went by bus to Amsterdam and Rome," June remembers. "Sometimes, we only had fifteen minutes to board the bus for the next destination. But Mary was gone. If you stopped, she'd shop. And she ate everything you weren't supposed to, and we warned her she was going to get sick. But she didn't. Eileen and I had ice cream in Paris, and got deathly ill."

On a trip to New York, Mary saw someone wearing glasses with frames that resembled a butterfly. She asked the lady where she might buy a pair, and what the style was called. The lady replied, "They're Winston glasses [so named for the English Prime Minister Winston Churchill] because Winston loved butterflies." Mary so loved them that she found the shop that sold them and bought three pairs in tones of black, white and pearl. The glasses became another trademark that easily set Mary off among any crowd. June said Mary was wearing her butterfly glasses while they were watching an old man ice skating in Rockefeller Center. Mary said, "You gotta give him credit. That old man's got guts." The skater apparently overheard Mary's remark. He skated up, looked her right in the face, and said, "Lady, you got guts, too—wearing those glasses."

On another trip to New York, together they attended the opera. June knew the lady who was vice chairman of the Metropolitan Opera. "We had reserved box seats for us and Father Bud. Mary loved it. She was in her glory. She told me, 'If I died tonight, I'd be happy.' Father Bud was attached to St. Patrick's Cathedral in New York, and whenever we'd come to visit, he'd take us downstairs to a private chapel, and said Mass for us. Mary always used to tease me because I didn't go to church. Her religion was very dear to her."

June rode out Hurricane Camille with the Mahoneys and about ten other family members in the house on the beach. She said she'll never forget it. "It was a Sunday, and Mary was cooking her typical Sunday dinner—pot roast, potatoes—what she called Bob's typical Irish menu. At that time, we didn't know the hurricane was coming into the Coast. Everyone kept saying it was going into New Orleans. Around noon, the doorbell rang, and I went out to find this little, old church lady outside. She was selling rosaries made out of cord, and

I bought a pair for 50¢ and stuck them in my pocket. At the height of the storm, when water was coming into the house, and the family retreated higher and higher upstairs, Bobby grabbed the beads out of my pocket, and he started leading us in the rosary. Nobody even knew Bobby could pray."

June said it was Hazel Pitalo who called her to tell her about Mary's illness. "She told me Mary was going to need a lot of help, and I had just retired, so I was able to be with her on weekends or whenever she needed me." Mary had always been there for June. She was especially supportive when June found herself without a long time companion. "I was so distraught. She probably saved my life," June said. "She called constantly. She'd call every Friday, and she could tell how I was doing by the tone of my voice. She'd say, 'Get your butt in that car and come over here right now.'"

June was there for Mary, too. "One time, after her first operation, she asked me to drive her to her cousin Clara Drago's house in Metairie. On the way back, Mary had some kind of seizure in the car, and she couldn't remember if she had taken her medication. I felt so helpless. I stopped at a Walgreen's in Metairie, and we called George Pitalo [a druggist] in Biloxi, and he told the druggist what Mary needed. It calmed her down, but I was shaking all the way back to Biloxi." June often accompanied Mary to New Orleans for doctor's visits. At that time, Mary had gotten off the straight gin, and she and June were drinking what she dubbed "Mobile cocktails"—vodka mixed with water. "I asked her if the doctor knew she was drinking, and she said she had told him. I guess I didn't believe her, so I asked the doctor myself if Mary should be drinking. The doctor winked at Mary and told me, 'Mary knows what she can do.'" June was with Mary the night she entered Biloxi Hospital for the last time. She had planned to return to Biloxi the weekend on which Mary died, but something came up and she didn't make it. She received a call from Bobby's wife, Sandy, that Sunday night saying Mary had passed away. "I'll never have another friend like Mary," June says. "and I miss her every day."

June wears a beautiful dinner ring on her hand—a present from Mary. "I wear it all the time, and every time I wear it, I think of Mary and the times we had together. I will never forget her. I still see the family often. I love them all."

Georgo Trojanovich

The story of how a young Yugoslav boy of fifteen, who spoke no English and had no trade, came to be Executive Chef of a nationally acclaimed restaurant is a fairy tale that only Mary Mahoney could have masterminded.

Georgo Trojanovich grew up in the remote village of Tresteno in the former Republic of Yugoslavia. His father, Niko, was Mary's uncle. Niko was six years old when Mary's mother immigrated to Biloxi. Now a grown man, Niko was eking out $20 a month farming and doing masonry work. It was a meager existence, but he was able to provide for his wife and two sons, Miho and Georgo.

Mary made her first visit to Yugoslavia in 1969, and went to see Niko and his family. Mary was thrilled to meet an uncle she had only heard about, and to see the village of her ancestors where her mother was raised, but she was also saddened and appalled by the poverty of the place. She told Uncle Niko she was in the restaurant business in Biloxi, and he should come over to work in the kitchen. She would

Mary's guidance and support helped transform grand nephew Georgo Trojanovich into one of the premiere chefs on the Mississippi Coast.

pay for his flight to New Orleans. "Hell," she promised him, "you can make $150 a week, just washing dishes." Niko took Mary up on her offer. He wanted money to put his boys through college and create a better life for his wife and family. He arrived in Biloxi near the end of 1969, and went to work for Mary at the restaurant. He lived with Mary's parents, saved his money, and sent something home every week.

Mary made another visit to Tresteno in 1971, and this time invited Niko's wife, Maria, and the boys to come to Biloxi. "I'll never forget the day—June 16, 1971—" Georgo recalls. His eyes still widen as he talks about landing at New York's LaGuardia Airport. "None of us could speak or read a word of English. We were supposed to take a shuttle at the airport to connect with our other flight to New Orleans, but we didn't know that. We got off the plane and wandered around. We showed our tickets to people we would stop at random, and asked people for help. But you know New York. Nobody would help us." Georgo said they had wandered around the airport for about twenty-six hours when they saw a man carrying a sign with the family name "Trojanovich" spelled out in Yugoslav. Mary and Bob had gotten worried, because the family had not arrived in New Orleans on their scheduled flight. They contacted airport authorities in New York for help locating their relatives.

When the plane arrived in New Orleans, Mary and Bob greeted the tired threesome. Although Georgo was exhausted, the adrenaline was pumping. He was so excited. He had never flown on an airplane before, nor traveled more than fifteen miles outside his village. He had seen very few automobiles. Mary and Bob took the weary travelers to a fancy hotel in the French Quarter to spend the night. They would drive to Biloxi the next day. Georgo remembers the bathroom at the hotel. "We didn't even have running water in our village. I didn't know how to turn on the shower."

The family stayed with the Mahoneys in Biloxi for three months, but Maria had to return home with son, Miho. He was in college there studying to be a ship navigator. Georgo had found a new home. He asked Mary and Bob if he could stay on and work in the kitchen with his father. "Of course you can," Mary said, speaking in her fluent Yugoslav. She convinced Maria that Georgo would work and

go to school, too. "Everything will be okay," she promised. "I started working right away," Georgo recalls, "making about $1.35 an hour. I worked sometimes sixteen, eighteen hours a day. I washed dishes. I bussed tables. I cleaned. I did whatever I was asked to do in the kitchen." Georgo says he still has the check stub for his first two weeks' pay. "I cleared $240. It was the most money I had ever seen."

Mary and Bob kept their promise and sent Georgo to Notre Dame [Catholic] High School. He worked in the afternoons and at the restaurant at night. But Georgo had trouble speaking and writing English and asked Mary if he could drop out of school. He did, and along the way, he began to learn to speak English. He also learned all there was to know about cooking, apprenticing under Chef Marshall Scott.

At nineteen, Georgo married, and moved his new bride into a house he built himself in North Biloxi with the money he had earned and saved. But the marriage lasted only about a year. "We were both too young," he says in retrospect.

Georgo continued to apprentice in the kitchen, and attended cooking seminars in New Orleans. He helped cater larger and larger parties and banquets. He took over as head chef around the time the Mahoney's daughter, Eileen, was married in 1980. Georgo took great pride in preparing the food that was served to over 3,000 guests in the restaurant and adjoining courtyard. His Lobster Georgo and other special creations have earned him raves from patrons and food critics, and he has been featured on local and New Orleans talk and cooking shows.

Georgo will never forget cooking on the White House lawn for President Ronald Reagan in 1984. "I got my U.S. citizenship in 1976, and that was a proud moment, but cooking for the President ranks right up there, too."

He credits Mary for steering his life in the right direction. "Mary was really the person who got me where I am today. She had a great love for everybody, but was especially loyal to her family. She was the greatest person I've ever known, and I felt a great loss when she passed."

Georgo's mother still lives in Tresteno, which is now in Croatia, where the fighting has been most intense. He slipped back into the

country in 1992, but his mother wanted to remain there. She's now in her seventies, and doing fine. He talks on the phone to her every Sunday. His father, Niko, returned to Tresteno in 1980, and died in 1991. Brother Miho is now a sea captain, having fulfilled his dreams as well.

Georgo married again in 1982—Debbie Ridgeway of Ocean Springs. They have two daughters, Season, and Kahla, and a son, Niko. They live in Ocean Springs in the third house Georgo has built since arriving at the Coast almost penniless in 1972.

Mary would be proud.

Gail May

Gail May operated Magnolia Memories, the unique gift shop in the courtyard behind Le Cafe and the Irish Pub, for nearly fourteen years. She never dreamed she could run a retail business, but Mary knew. "I opened here because Mary wanted me here," Gail says. "I don't know whether to thank her or cuss her. But the payoff has been my association with Mary. I will never forget her."

Gail, who was born and raised in Moultrie, Georgia, came to Biloxi with her pilot husband, Ron, in 1979. He was Commander or the Hurricane Hunters Squadron stationed at Keesler Air Force Base. The Irish Pub Lounge next door to the restaurant was a favorite hangout for the squadron, and the wives would meet their husbands in the evenings when Mack Taylor was playing the piano. "That's where I first met Mary. We became instant friends. I knew when I first met her, she was one of those special people. She had this huge aura about her."

Mary helped Gail and other Air Force wives plan special parties, and she always felt that Gail's husband had an inside track on the weather. "She'd call him sometimes late at night to ask him if it was going to rain next Wednesday or whenever, because she was planning to have something in the courtyard. She'd say, 'Ron, don't let it rain. It just can't rain.'"

One day Mary discovered Gail was selling some 14-carat gold jewelry to customers who frequented a beauty shop across the street

from the Old French House in the Fountain Square shopping center. Mary went to have a look at it, and she called Gail late the next night. She said, "Dawlin, I think you should come down and open a little shop in my courtyard. I think you can do real good." "I was scared to death," Gail recalls. "And more than a little shy. I told her I didn't know anything about running a retail shop. She said, 'I tell you what. You just go in there. We won't even talk about rent. I want you in there.'"

So Gail's Gold Connections opened up in 1980, and she stayed in the little shop until 1984, when Mary made her another offer during a second late night phone call. "She said she wanted me to move over to her Mexican Market gift shop. She wanted to get out of that business. I told her I already had a name picked out: Magnolia Memories. 'That's good,' Mary said, because the name had a double ginza [MM]. She believed in double ginzas. She said it was a sign I'd have good luck. Mary later confided to me that I was a good personality to have around the restaurant."

Mary and Gail became close friends, frequently going on shopping trips and attending Broadway road shows that came to New Orleans. Gail said she and Mary were competitive shoppers. "We wouldn't shop in the same store. We'd go off on our own, then afterwards, we would compare to see who got the best bargains. If I found something she particularly liked, she would say, 'If I'd have seen that first, it would be mine.'" And when Gail had something Mary liked, Mary would let Gail know she wanted it. One particular item was a dainty black, antique Victorian evening purse Gail had found. It could be held in one's hand or clamped to a dress belt. It was a perfect companion for Mary's opera glasses. "I gave it to her on her birthday one year, and I put a little note inside asking her to will it back to me," said Gail. Mary didn't forget. Even in her illness, she instructed daughter Eileen to return the purse to Gail. "And every time I use it, it brings Mary back so strongly," Gail says.

One time, Gail and Mary took off to Florida alone. "I had gold concessions at some of the military bases along the Coast, and I made frequent trips down to one in Panama City, Florida. I told Mary I would stay at this little out-of-the-way place called Mexico Beach, far away from everything, and one time, she asked if she could go

with me." This was after Mary's initial surgery. Driving down, Gail convinced Mary to use a small recording machine to tape memories of her starting out at the Old French House [some of which were used in research for this biography]. "After we got to Mexico Beach, I left Mary alone with no place to go, no transportation, and I went about my business," said Gail. "I told Mary just to relax and enjoy the quiet. She talked the motel owner [a good friend of Gail's] into taking her to a hardware store, because it was the only place to shop down there. She picked up all kinds of stuff she didn't need, and probably would never use. Another time, we went to eat in a little restaurant there, and Mary fell in love with this picture. She talked the owner into selling it to her. Nobody could say no to Mary."

On that same trip, Gail planned a birthday party for her brother Tony and his family, who were driving in from Georgia. Mary had not met Tony, but she had eaten some of his Georgia peaches which Gail frequently brought to her shop. "Of course, Mary wanted to be in on the party. She genuinely loved to be around people. And she instantly fell in love with my brother. She picked up the tab for the entire party, and I told her I didn't want her to do that. But it was just a spontaneous thing with Mary. She said, 'Tony was special people. My dad was a Tony.' We had great fun that evening. And my whole family jut fell in love with her."

Gail found ways to pay Mary back for her generosity. "She had invited me to go with her to a party in New Orleans given by the Rouse Company when they first opened up the Riverwalk. They thought Mary might like to do a little gumbo shop restaurant there, and Mary thought I might like to open a small gold shop, too. We stayed at the Windsor Court Hotel. I had them deliver breakfast to Mary in bed—complete with a rose. She loved that. And when her hair started coming out from her chemotherapy treatments, I ordered her a 'Mary Mahoney wig.' She was so proud of it." Gail makes it a point to say she doesn't mention the incidents to flaunt her own good deeds. "It is just the sort of thing Mary would do for others, so she deserved in-kind treatment."

Gail had open-heart surgery in early 1984, and Mary was there for her. She remembers the first sign that something was wrong with Mary. "I think it was on St. Patrick's Day in March of 1984. Goofy

was one of Mary's favorite words. We were out on the patio, and she grabbed me, and said, 'I got this goofy feeling today. I just feel so goofy. I think my eyeglasses might be going bad. I feel so dizzy. I can't even walk a straight line.'" Mary had a habit of picking up glasses that someone left around the restaurant or buying off the rack reading glasses, but Gail convinced her to go to a local opthomologist for an eye examination and prescribed lenses. But Mary's dizziness and disorientation continued. The fateful diagnosis that Mary had a brain tumor came after she went to Ochsner for a CAT scan.

"Mary was not a person to sit around and say, 'Oh! My God, I'm dying,'" Gail recalls. "She carried on, and she had her quiet, sad moments. I was with her for a couple of them. But she continued to be just a wonderful hostess around the restaurant until her health began to fail. She would listen to other people's sorrows rather than dwell on her own. She realized we were sent here to be joyful creatures, and so, Mary was a person of great joy. And yet, in her own way, she was a very spiritual person too—I had always sensed that."

Gail remembers Mary's charity towards others. "She had a heart—a big, big heart. She was charitable to so many people. The town would never know about it, and no one would know but Mary and that person. She would recognize people with a need, and she would quietly take care of them. Sure, probably some people took advantage of her, but she would take care of them if they would come and ask for help. Or if all they needed was a meal, Mary gave them a meal."

Gail said some people worried that the restaurant would not survive and prosper without Mary. "Mary was a gift, and she had to leave us way, way too soon. And she left a great legacy. And, it's still there. That's the amazing thing. Many people said it won't be the same. And, of course, it isn't. But her spirit is in so many places around here. Late at night, I can almost hear the clickety-clack of her slippers on the walk on the patio, and almost see her greeting people at the door in the beautiful gowns she wore. She has left an aura here. And those who knew her still sense that."

George and Hazel Pitalo

George and Hazel Pitalo shared many good times and wonderful trips with Mary and Bob. George's mother and father were close to Mary's parents, and George was one year behind Mary in school at St. Michael's and Sacred Heart. He remembers Mary as "one tough girl. Nobody pushed her around."

George was one of the regulars at the Tivoli bar, too. "She always had records playing, and you never knew what she might wear. She was really into state and local politics. She knew the politicians, and she knew who to get close to, but she personally made everyone who came there feel like they were welcome."

Pitalo is among those who witnessed Father Mullin's influence over Mary's life. "He was a real advisor to her. He always guided her in the right direction. She depended on him a lot in making decisions. He convinced her that area of East Beach [where she wanted to open the restaurant] was hot." And Pitalo said Mary never forgot her mentor. When the pastor retired to Pompano Beach, Florida, "Mary bought him a new car, and drove it down to him."

The Pitalos remember trips with the Mahoneys like they happened just yesterday. "One time we were staying at the Top of the Mark in San Francisco," Hazel said. "We had eaten dinner, and returned to our separate rooms, and George and I decided we would just go out again, and maybe walk around town in the fog. A knock came at the door. It was Mary—still all dressed up. 'You thought you were going to sneak out without me, you turkeys,' she said. You couldn't put anything over on Mary. There was no getting one step ahead of her."

Another time the Pitalos were on a Caribbean trip with the Mahoneys, and Gabe and JoAnn DeGregorio, and Jerry and Annette O'Keefe were having dinner at a restaurant in St. Thomas. A group at the next table was singing 'Happy Birthday,' and the Biloxi group joined in, and exchanged introductions. "Somebody asked, 'Have you been to Mary Mahoney's,'" Hazel recalled. "And Mary grinned that big grin from ear to ear, and announced as proud as a peacock, 'I am Mary Mahoney.' It happened again on the plane coming back."

One time Mary conned Hazel into flying out of Pascagoula with her on a single engine plane. She wanted company to go to Natchez

and receive an award, honoring her as Mississippi's Small Business Person of the Year. "I told her I didn't think George would let me go with her, and especially in that little plane. But she was calling me from George's drugstore, and she had already talked him into saying I could go. "On that little plane, we were both scared to death, and there were no cocktails. It was lightning and thundering the whole way there, but Mary never admitted she was scared. The mayor of Natchez met us at the airport, and we partied all night. I didn't know how Mary was going to get up the next day to accept the award at a luncheon, but she woke up way before me the next morning, and looked like a million dollars." Hazel made Mary promise that they would go to Jackson the next day, and return to Gulfport via a jet.

Hazel also accompanied Mary on trips she made frequently to Merida, where she bought merchandise for her Mexican Market. "Mary knew where all the shops were—on the back roads. She had no fear. Mary would carry six suitcases inside one big suitcase. She filled them up, and we divided them up among us, so we could get passed Customs."

George and Hazel said Mary's generosity, especially to her close friends, was legendary. "She'd take great pride in delivering poinsettias to friends at Christmas, and, of course, she'd get lost going through the winding roads in Gulf Hills, where we live, so she'd call me for directions," Hazel said. Hazel remembers when Mary and Bob were robbed in their apartment above the restaurant. "The police had some suspects, but Mary wouldn't press charges," she said.

George and Hazel have twin daughters, Lynn and Susan, who grew up with Mary's daughter, Eileen, and Mary O'Keefe, one of Jerry and Annette's daughters. The twins decided to have a double wedding, and planned to have the reception on the lawn at the Tullis-Toledana Manor. "But the weather was threatening, so Mary had Gail's [May] husband fly into the clouds, and check things out. He was with the Hurricane Hunter Squadron. She moved the reception to her patio. She said God never lets it rain on my parade, and it didn't," said Hazel.

The Pitalos also remember the quiet, special moments they shared with Mary. "Sometimes, we'd be home for the weekend, and Mary would call, and say, 'What are you turkeys doing? Come on down.'

So, we'd get out of our night clothes, get dressed and go down to the restaurant and sit on a bar stool, and drink martinis with her. Sometimes, it was eleven at night before we would eat." Hazel continued, "Mary absolutely loved that restaurant. She used to tell me, 'Hazel if I'd ever lose this place, I'd pay someone to let me work here.'"

Hazel, a registered nurse by trade, shared even quieter moments with Mary after her illness was diagnosed and later through the surgeries. "She never complained, and she never cried." The Pitalos drove with Bob to Ochsner's to be with Mary after the second operation. "It was Super Bowl Sunday, and the roads were iced over," Hazel said, "but Mary was in good spirits. She had won part of the football pool. She loved football, and especially the New Orleans Saints, but she'd bet on anything, and she loved to win."

The Pitalos were also included in family affairs, like Bobby's and Eileen's weddings, Mary's annual Fourth of July parties, and Easter Sunday dinners when all the family gathered and the restaurant was closed. "And New Year's was special," Hazel recalls. "She used to dance behind the bar, and she never seemed to run out of energy."

Like Mary, Hazel was a past Queen of Young Matrons, and the two frequently went together to carnival balls in Biloxi or in New Orleans. "One time we went to the Bacchus extravaganza at the Rivergate, and on the way back home, in the car, Bob said we were having such a good time, nobody noticed he had on two different shoes. We laughed about that all the way home." Hazel continued, "We always had a wonderful time together, and Mary's zest and love for life was contagious. You could not have a bad or dull time when you were out with Mary."

Diane (Catchot) Cothern

Diane (Catchot) Cothern frequented the Slave Quarter bar at the Old French House with Barbara Trahan, Jean (Moran) Kuluz, and others from Sacred Heart All Girls Academy. Diane met Glen Cothern there, but doesn't know how much Mary had to do with that. Glen and Mary had known each other since the days when Mary ran her lounge at the Tivoli Hotel. Cothern was the Budweiser representative for Rex Distributors, and he and Mary shared many a good time

Bob and Mary Mahoney shown dining in Bermuda with friends Diane and Glen Cothern. The couple frequently traveled with the Mahoneys.

together. Diane and Glen married in 1979, and they were always included in Mary and Bob's close circle of friends.

Diane remembers Mary loved to plan trips to include her friends. "Of course, you'd always go first-class, but it didn't work out that way sometimes. She could get us into some messes." She remembers when the group went to Cancun, Mexico. While there, Mary organized a ferry ride to nearby Cozumel. "We were all dressed to the hilt, and we got on this ferry with chickens and pigs, and God knows what else. And the water was washing up over the boat. By the time we got there, we all looked like drowned rats."

Another time, Mary decided it would be "fun and romantic" to ride the Amtrak first-class to San Francisco. Diane and Glen went along with Mary and Bob, Jerry and Annette O'Keefe, and George and Hazel Pitalo. "It cost more than flying first-class, but Mary painted this wonderful picture of riding the rails out West, so we just had to try it. Turns out, the showers weren't working in our sleeper cars. And dining wasn't exactly what we expected. Instead of fine crystal and china and being waited on hand and foot, we ate out of paper plates. "I think we got as far as Los Angeles, and they were going to

bus us to Carmel or somewhere to catch the Amtrak into San Francisco, but Glen was running out of patience by then. He talked Mary into forgetting the rest of the trip, and we flew into San Francisco."

Everywhere they traveled, Mary loved being in the limelight, Diane said. "She never met a stranger. She'd talk to everyone. And she wanted to make sure everybody knew her. She loved to wear those butterfly glasses. I don't care where we went. She made people stop and stare. They all wondered who she was. She loved all that—the attention. She was always passing out her restaurant matches, always promoting her restaurant and Biloxi."

Diane credits Glen and Mary for starting Biloxi's Hibernia Society, which eventually led to the city's first organized St. Patrick's Day celebration downtown. (Mary was named honorary parade grand marshall in 1985). "They were sitting around talking one night, and Glen said we ought to have a really big celebration. He told Mary he'd throw in a couple of kegs of green beer if she hired a band, and set the thing up in front of the [Irish] Pub. And that's how the whole thing got started. It keeps getting bigger and bigger every year."

Mary and Glen were both "generous people," Diane said. "One year when the city was hosting the annual Miss Teen USA contest, Mary had all the contestants at the restaurant. She and Glen noticed this one girl—kind of a loner—and started talking to her. She was excited and proud to be a contestant representing her state of Montana, but a little sad that her folks couldn't afford to come to the pageant to cheer her on. So Mary and Glen called them up, and told them they were making all the arrangements—to get themselves packed and get on the next plane. They paid their way to Biloxi and their accommodations; and they wouldn't take no for an answer."

Glen died in 1991, and Diane hosted a small group of friends in the Herald Room of the Old French House Restaurant after his funeral because, she said, "Glen would have liked that." A few months later, Bobby called and asked Diane if he could rename the Herald Room the Glen Cothern Room in her husband's honor. "He said his mother would have wanted that, and I thought Glen would like that, too." So, they had another reception to re-christen the room.

Diane said Mary's zest for life never waned, especially in the early stages of her illness. "I think she actually believed she was going to

whip it. She had me convinced. As soon as she would get out of the hospital after her operations, she would regain her strength. She'd put on her wig, dress to the hilt, and greet her customers every night, until she couldn't do it anymore. "She dearly loved that restaurant. In the early days, she was the last one to leave at night and the first one up in the morning. I don't know how she did it. But the restaurant was her stage, and she played the part until she couldn't anymore. She was an inspiration to us all."

Bob and Anna Wilkinson

Bob Wilkinson retired from Mississippi Power Co., after thirty years of service. He knew Mary's family all his life, and used to "shoot the breeze" with Mary's father at the grocery on Main and Bayview. He and Mary's brother, Andrew, are the same age, but Andrew went to Notre Dame and he attended Biloxi High.

"I used to watch Andrew doing restoration work before the Old French House opened," Wilkinson said. "I started bartending first at the Sun-N-Sand, and Mary and Bob used to come in at night. In 1968, I asked Mary if she could use another bartender, and Mary put me on." Wilkinson worked in the Slave Quarter bar for about a year, then was lured back to the Sun-N-Sand. "But Camille came, and blew it away. I called Mary, and said I was out of a job, and Mary said, 'Well, come on back.'"

Wilkinson became a fixture at the popular watering hole, and worked full time until 1989 when he suffered a heart attack. He still serves as "bartender emeritus," stopping in at night and helping out, mainly on weekends. "Mary was the greatest person to work for," Bob brags. "In all the times I bartended, I never once saw a fight break out. Sure, there were some arguments—that can happen in any bar. But Mary had a way of soothing things over, and she could calm people down. I never once had to call a policeman in for any reason, and that's something to say when you're running a bar."

Bob was bartending one night when Mary came to his defense, too. "I fixed a guy a martini, and I think he was kidding—trying to get Mary's goat. He told her that was the worst martini he ever tasted

and I was the worst bartender he ever met. And Mary got right in his face, and told him I was one of the finest men he'd ever meet, and if he didn't like it, he didn't have to stay, and he could take his business elsewhere. Then the guy laughed, and it was all over. I think that's why Mary kept so many of her employees over the years. She loved them, and she was good to them."

Wilkinson was there to survey the damage after Hurricane Camille. "We were lucky. A few bricks flew down the chimney, and the bar took on some water, but everything else in the restaurant was fine." The bar became the regular hangout for power company workers and other crews repairing the damage. "They made the bar their head-quarters, and in the afternoons, you literally had to push yourself in to get through the door."

Bob also remembers some of the celebrities who came: television personality Bob Barker, Saints quarterback Archie Manning, and Alabama Coach Bear Bryant. "Bryant had two bodyguards posted in the patio while he ate. And Archie's kids used to play in the patio with Bobby's young ones."

Wilkinson remembers the good times, too, like Eileen's wedding reception, St. Patrick's Day parties, and all the fun around the holidays. But most of all, he says, he will cherish the special times he had with Mary. "She'd be greeting people and getting them settled into a table, and she'd come by and ask me to fix her 'a little martini.' I'd fix it, and she sipped it all night. Then after the crowd cleared out, we'd talk as long as she wanted to talk. And I'd listen. That's what a good bartender does."

Anna Wilkinson, Bob's wife, was another friend Mary took under her protective wing. When Bob started bartending for Mary in 1968, Anna was working as a secretary for the Tax Collector's Office at City Hall. But Mary recruited her to "come in after work and stay a couple of hours" tending her Mexican Market in the newly opened rear courtyard behind the Pub and Le Cafe. "Mary really didn't care what I did," Anna said. "I would work a couple of hours and could sell anything I wanted for what I wanted. As long as we were making a little profit, she didn't care, and she never worried about anything."

Anna remembers Mary taking friends on buying trips with her to Merida, and "coming back loaded down with all kinds of things for

the shop. One person could only bring is so much tax-free merchandise, so she'd recruit two or three friends, and they'd go on a buying spree for two or three days and come back." She recalls one time when Mary came back with "a bunch of those Mexican shirts with all the embroidery and all the pockets. Everybody who was a regular in her bar just had to buy one. And when all the men got together and wore them, they looked like some kind of mariachi group or something. Every time I sold something, Mary would get so excited. I don't care if I sold $5 or $500. She was always so complimentary. And if I didn't sell anything that day, she'd say, 'Oh! Hell! Tomorrow's another day. Don't worry about.'"

Anna said one time Mary went rummaging in her attic and came down with "some really old looking bowls." She told me to clean them up and sell them. 'Get whatever you can. I don't care what you sell them for.' Well, one night this man comes in from this antique shop in Slidell, but I didn't know he was a dealer until he gave me his card afterwards, and he bought one of the bowls for $40, I think. And Mary comes back, and I tell her I sold the bowl for $40, and Mary thought that was wonderful. Then I showed her the man's card, and Mary realized the guy was an antique dealer. 'Oh! My God. Oh! My God!' Mary screamed. 'What have we done? That thing must have been worth a fortune.' I felt so bad, but then, Mary got that big grin on her, and hugged me, and said, 'What the hell! Don't worry about it. He might have made some money, but we made some money, too.'"

Mary also put Robert, one of Anna's sons, to work, as a bus boy. "But she was so protective. He was running around hauling the dishes off the table, and Mary would say, 'Now, sit down awhile. Don't get too tired.'" She later got Robert a job with Rex Distributors, where he is still employed.

Anna remembers Mary as a very compassionate person. "Poor people would come looking for a handout or a free meal, and she'd take them over to the cafe and tell somebody to get them a good meal. Traveling priests would pass through from Mobile on their way to New Orleans, and Mary would feed them, too. She never turned anybody away. She was one of a kind."

Barbara (Cvitanovich) Lyons
and Elda (Trahan) McGill

When they were first married, Mary and Bob rented an apartment for about six months from Mary's uncle Dominick Cvitanovich on Howard Avenue, and his daughter, Barbara Cvitanovich (Lyons) remembers their comings and goings.

"I think Bob was working as night manager at the old Beachwater. Bob would get home before Mary because she'd be out on the Bay helping in the grocery store. She'd come in our house and she'd ask my daddy, 'Where's that son-of-a-bitch?' One night, she came in and Daddy was sitting in his chair reading his paper or something, and she said, 'Where's that son-of-a-bitchin bastard?' And my Daddy, being of European descent, looked up at her and said rather dryly, 'I always wondered what his last name was.'"

Barbara remembers when Mary's son Bobby started to school. "He'd stop at our house and have breakfast. And in the afternoon, he'd come into Daddy's store and pick up something. He'd tell my dad to put it on his mom's account."

She remembers Mary's grand entrance when she was Queen of Young Matrons. Barbara and Eunice Johanson made Mary's costume in 1961 when she was Queen of Le Femmes Carnival ball. "Pete Elder was king, and Mary wore a strapless dress that took us three months to glitter. It had to look like cracked ice. And she wanted this black tulle coming down from her headpiece, and I think we had about twenty-five feet of tulle running through the house."

Barbara and her best friend, Elda Trahan (McGill), both went to Mary's lounge at the Tivoli during their early married lives. In fact, both had their wedding receptions there. Barbara is married to Steve Lyons, and Mary and Bob are godparents to their daughter, Adelle, born in 1964, just before Mary opened the Old French House Restaurant.

"At the Tivoli Lounge, Frances Mattina [Dalton] often opened up the bar," Barbara recalls. "Then Mary would come down about ten or eleven. Chances were, Elmer Williams, Specs Peretich, Jerry O'Keefe, and Skeeter Cangemi were already at the bar. After Steve and I married, we'd go down at night and listen to the music or play

darts. She loved to play Frank Sinatra. She had most of his records, but she had so many records, I couldn't count them—from pop to opera. And when the bar closed, Mary would hold court every afternoon in the little breakfast room at her house on the beach. Mary couldn't afford to buy the booze, so they all brought their own."

Elda Trahan worked for Mary about twenty years, beginning around 1971. "I started out as a bookkeeper, then secretary. Mary kept all the records for the business stacked in boxes, and I had to organize them and make some sense of them. At that time, they already had thirty to forty employees. Then I sometimes helped out as hostess and bartender. I remember the first time Mary asked me to 'fix her a little martini.' I was scared to death; I put it in front of her, and thought she was going to throw it at me. But she didn't."

Mary loved to gamble, Barbara says, and would "bet on anything." "She'd place her bets with Nicholas [Canine] Filipich, when he ran his bookie joint on Caillavet Street, and that's where Bobby would hang out. Canine would always say he was going to own the restaurant one day. But Bob would always pay off her gambling debts every Christmas, and, of course, little Bobby would throw his debts in, so they'd get paid, too."

Elda remembers Mary loved to "go out with the girls," and they would sometimes go to the fairgrounds in New Orleans. "We'd stay for the whole twelve races, and Mary would bet on anything that had a ginzy name [double letters like Slippery Sam or whatever]." Barbara drove the group to the track and around downtown New Orleans more than one time. "I remember one time Mary was supposed to get back to the restaurant for something that night. I think Elda was with us and Suzy Patronas, and Mary Rose Dubas [Leahy]. Well, after the races, we just had to go to the French Quarter, and we started out at the Carousel Lounge in the old Monteleone Hotel. Mary had to call Bobby and tell him we'd be a little late. We all got a good buzz on, and Mary decides we're walking on to another bar at the Royal Sonesta because Mary loved to hear this Spanish guitar player. So, we get out on Royal Street, and Mary has this silver whistle around her neck and she blows it to stop the traffic, and let all of us cross the street. It was a hoot." Elda chimed in, laughing, "I'll bet people were thinking, 'there goes the Madame and all her girls.'"

Barbara and Steve joined Mary and Bob and others in "their entourage" when they went to Las Vegas. "Mary would go through her money and ask Steve to borrow more, but not to tell Paw-Paw [her nickname for Bob]. Of course, she'd always pay him back."

Another time, Barbara and Suzy Patronas went to a convention of dieticians in Philadelphia, and Mary talked them into going on to New York, and she flew up to meet them. "We all stayed at the Plaza, and Mary knew these Seagrams distributors, who took us out to lunch at a small, uptown, very expensive restaurant. Father Bud was stationed at St. Patrick's then, and he joined us. We had a wonderful time, and they invited us to dinner at another restaurant that night. Father Bud was wise, he bowed out, but, of course, we went. It was another fancy, uptown, very expensive restaurant, and Mary and I ordered the most expensive things on the menu, so we could taste each other's food. And the drinks were flowing. And they ordered the most expensive champagne on the menu. Our waiter was a good-looking, young Yugoslav, and Mary starts talking to him in Yugoslav, and we're having a ball. She was wearing this black Madame Butterfly wig with the bangs, and it kept slipping down, so she excuses herself to go to the bathroom and straighten it, I guess. Seems like a good time passed, and the young waiter tells me I need to go to the bathroom and check on my friend. The bathroom was a little closet of a room, and I pushed on the door, but couldn't get in. I yelled, 'Mary, are you alright?' And I heard this little tee-hee, like she'd do when she got a little tipsy. 'I'm okay,' she said, 'but you got to come in and help me.' She was leaning on the door, and when I pushed my way in, she was still tee-heeing, and she had this shit-eating grin on her face. She had pulled her girdle down, and she couldn't get it back up, and the whole time I was helping her, we were both laughing so hard, we almost peed on ourselves. So, we get back to the table, and I told her she missed the expensive champagne, and she says, 'Can you just pour some in my mouth, so I can say I had it?' Getting back in the Plaza was a hoot, too. They had a revolving door. I think I pushed her in, and Suzy was on the other side to catch her."

Barbara remembers Mary's voracious appetite. "They used to call her the alligator. One time we all went to the House of Chin after it first opened, and we all individually ordered. Mary would scoop up

everything on her plate, and yours would be half-full, and she'd ask, 'Are you going to eat that?' When it came to eating, she was on the first team."

Barbara and Elda and Mary shared a love for dresses. "Mary loved to go shopping at Helen Shamis's shop on Teagarden Road, and sometimes we'd go with her," said Barbara. "And they served wine or cocktails while we shopped, so they knew what they were doing," joked Elda. At one time the three all wore the same size dress, and often—especially on formal occasions—Mary would let them into the inner sanctum of her bedroom closet to pick out a dress to wear for a special evening. "I loved this pink chiffon, pleated dress with ostrich feathers all around it. I wore it when Eileen was Queen of the Mardi Gras, and several times after that," said Barbara. "I offered to buy it several times. I could barely fit in it, and Mary had gotten bigger than me, but she always said, 'No, I'm gonna get back down to that size one day.'" Elda added, "She had clothes in her closet that still had the price tags on them. And she always had somebody sewing something else for her."

Elda remembers another "fashion event" that happened shortly after Mary opened the Carriage House addition to the restaurant. "All she told me was that a group of about thirty had reserved the place that night, and I was to greet them and make them comfortable." Turns out the group was made up of cross dressers—most of whom came with their wives. "At first, I was in a bit of shock—especially because one of them had on an identical dress I had in my closet. But, as a whole, I got over the shock, and they turned out to be delightful, wonderful people. They came back year after year."

Elda left the employ of the Old French House in 1995 to take a food and beverage management position with Boomtown Casino on Back Bay, not far from where Mary had started out at her dad's factory, and later toiled in his grocery.

"Sometimes, I think about Mary and what she would think about all these casinos," Elda said. "Bob would have to put her on an allowance," joked Barbara. "But she'd love it, and she'd be right in the middle of the action. She always wanted anything that was good for Biloxi, and if she thought the casinos would help the economy and the quality of life around here, I'm sure she would have been in the

forefront, like Bobby was, to bring legalized gambling to Mississippi."

Ginger Harwell

Ginger Harwell came to the Old French House in 1965, courtesy of the dynamo Mary talking her into becoming her maitre d' and staff organizer. "Joe Famiglio called me. I was working as a waitress at the Buena Vista. Mary and I hit it off right away. It was like being in my own home. You did what had to be done."

Ginger started out serving as a waitress downstairs, and one night Bob asked her to bartend. "I didn't know anything about mixing drinks. Bob said, 'We'll teach you, and if you don't like it, you can go back to what you were doing.' Mr. Joe helped me a lot, too, and I just picked it up. I bartended for four years. It was the most fun I ever had in my life. I met the locals, people from New Orleans who would come in to eat almost every weekend, and, of course, movie stars and people from all over the world. "Mary would be down at the bar in the early evenings, and she would greet everyone at the door. When the dining rooms started filling up, she'd hop from table to table asking them how the food was and just chatting with everyone. She didn't miss a table, and I sometimes didn't see her until late at night. Then she'd come down to the bar for her nightcap, and we'd talk about the people she met and what they had to say about the restaurant. We got to be best friends, and we were quite a duo—with my flaming red hair and her dark hair. Sometimes people couldn't remember my name, but they'd ask Mary, 'Where's that red-head?'"

Ginger remembers the Old French House was spared extensive damage when Hurricane Camille passed through in 1969. "The patio was a mess. There were tree limbs everywhere, and the water and mud came into the slave quarter bar and dining area," Ginger recalls. "But we were only closed for about four or five days. I remember having to come to work by way of the old Ocean Springs bridge because the d'Iberville bridge crossing North Biloxi was out. Mary wanted everyone to know we were open, and it was business as usual."

Ginger especially liked the times she and Mary would close the restaurant at 2:30 in the morning, and then go out to the Toddle House or somewhere for breakfast. "One night, we went out the back door,

and we were just sitting down for breakfast, and Bobby comes walking in. We had left the front door wide open, and he discovered it when he came in and went looking for us," she laughed.

Ginger went on a business/vacation trip with Mary and Hilda Covacevich. They flew to Merida, and spent a few days relaxing at a resort on the Yucatan Peninsula. "But somebody told Mary there was wonderful shopping and bargains to be found in a little mountain town called Oxuaula, so we flew there on some little plane." Both Ginger and Hilda got "Montezuma's revenge" on the side trip. "While we were near death, Mary shopped with a vengeance," Ginger teased. "We had garment bags stuffed so full, I had to drag them along with us. They were too heavy to carry." Mary was buying most of the stuff for her Mexican Market she had opened in the new addition behind Le Cafe and The Pub. "We were on our way home, and Mary still had lots of pesos, and they were closing the shops at the airport," said Ginger. "She kept banging on the doors for them to open up, because she still had money to spend."

Ginger enjoyed many other outings with Mary and Bob. She went to Saints games in New Orleans with them both and on shopping and theatre trips with Mary. She was considered part of the "in group" among their close friends. She continues to maintain friendships with most of the locals she met at the restaurant.

Ginger left Mary's employ in 1970, and opened a bar at the Trade Winds Hotel where Mary got her start. After that, she managed a bar at the White Pillars restaurant, then opened her own restaurant, Ginger's, in the Magnolia Mall in 1983, not far from Mary's, and ran it herself for four years. "Mary taught me a lot," Ginger said. "but I didn't know until I got involved in it, that the restaurant business is a very demanding business. She made it look so easy. But she was lucky. She had people around her to help share the load."

Maria Hopkins

Maria Hopkins met "Miss Mary" right before she opened the Old French House in 1964. "I was renting the house behind her on the beach owned by Victor and Gail Marvar. I didn't speak much En-

glish then, but Miss Mary and I would talk by the fence, and we learned to understand each other."

Maria went to work at J. C. Penney around 1968, and she says "Mr. A. J. [Swansine] must have told her I could sew. She wanted a new gown for every night. I couldn't turn them out that fast, but she always loved anything I made for her."

In 1977, Maria started working in the restaurant with Mary as a part-time hostess/bartender. "She did not treat me like she was my boss. She was more like my sister. She was a beautiful person. Her personality was her best feature. She was understanding and kind and giving, and she loved people, and people felt that."

Once when Mary went to visit her family in Yugoslavia, she stopped in Sienna, Italy, to see Maria, who was visiting her family. "She stayed with us for a weekend, and I had two brothers who spoke good English. Miss Mary talked and talked, and everyone just fell in love with her. Later I went to Florence with her to look for a wedding gown for Eileen. We went all over. Mary loved to shop."

Mary invited Maria to join her, Hilda Covacevich, and granddaughter Caty to go see Julio Iglessius when he was appearing at the 1984 World's Fair in New Orleans. "She knew how much I loved him. It turned out to be an even bigger thrill since he was staying at the Windsor Court, and we were staying there, too. So we actually got to meet him. I will never forget that."

As Mary's illness took hold, Mary became more reclusive, but Maria looked in on her at the upstairs apartment before going to work at the restaurant. She would sometimes spend nights and weekends with her, but Maria was in Italy visiting her ailing father when Mary passed away. "She left such a void, but we all had to pull ourselves together. Life goes on. She would have wanted it that way."

Maria continued to work at the restaurant until 1990, and she helped keep an eye on Mary's mother until she died in 1987.

Marion Williams

Marion Williams attended St. Michael's Elementary School at the same time as Mary, but was one year behind her in classes. He remembers that Mary and his cousin, Mercedes Williams (Hall), were

always childhood friends. "Mary seemed a bit shy to me, but the boys never hung around with the girls too much in those days."

Marion's uncle, Elmer Williams, who owned DeJean Packing Co., was one of Mary's best friends and regular customers at her bar in the Tivoli Hotel. As Marion grew older, he and his companion, Holmes Love, became regular patrons at the bar, too. "It was just a wonderful, fun place to go. The place was usually packed with all kinds of interesting people. Sometimes Mary would wear her Carmen or Madame Butterfly outfit or whatever opera she might be interested in at that time. And sometimes, like Halloween or Carnival, the customers would mask, too. Mary always had time to talk to everybody, and she made everyone feel so special."

He recalls hearing about Mary being forced to close her bar after the new owner took charge. "Holmes and I were living in Washington, D.C., at the time, but I know my uncle and all the other regulars were just devastated. He'd tell us the regulars would still go to Mary's house on the beach, and Mary would serve drinks in the afternoon, just like she was still running a bar. She didn't charge them. They usually brought their own supply," he laughed.

Marion and Holmes moved back to Biloxi sometime before Camille

Marion Williams, left, and the late Holmes Love flank Mary Mahoney as they posed for a picture for the Aberdeen Examiner *on a trip through the Mississippi Delta in 1983.*

struck in 1969, and they helped Mary get the Pub and Le Cafe ready for its grand opening in 1971. "We helped her decide what pictures to hang and where, and we introduced her to Steve and Debbie Geoffrey, some friends of ours from New Orleans. Steve played the guitar and would become a regular there, playing mostly on weekends."

Williams said St. Patrick's Day was always a festive occasion at Mary Mahoney's with a big tent erected outside the Pub and Le Cafe. "I remember one year when Mary dressed all in white with green shamrocks all over her. She looked wonderful. She was always so vivacious, so full of life."

Marion and Holmes had a thirty-foot Hataras Yacht, and often invited Mary and Bob aboard for the annual Blessing of the Shrimp Fleet or other occasions. "They went with us all the time on trips to Ship Island and everywhere. I think some people thought it was Mary's boat. She was on it so much."

He confirms that Mary was always a dreamer. "When she called us to tell us she was going to open a restaurant, we said, 'Mary, you don't know a damned thing about running a restaurant.' She said her cousin, Drago, had a restaurant in New Orleans, and she was going in for the day, and she would learn all about it."

Another time, Marion and Holmes invited Mary on a trip through the Mississippi Delta. Holmes wanted to visit his birthplace in Aberdeen. "Mary and I were fascinated. I don't think either of us had been above Jackson before." The threesome took their time, driving at their leisure in Holmes' stretch Cadillac limousine. "It was April of 1983, and they were having the annual Spring Pilgrimage in Columbus, but I think we went through Clarksdale, Greenwood, and Greenville, too. Mary remembered she had a girlfriend from Greenville, when she was in college at Perkinston. She didn't know where she lived, but she knew her last name. So Mary flagged down a highway patrolman and asked him if he knew where the family lived. And sure enough, he did. They owned a plantation, so we ended up having dinner with the whole family, and, of course, Mary was the center of attention. It was something only Mary could have done. Mary fell in love with a house there, too. It was an antebellum, and it was for sale. And she thought she might be able to cut it up and ship

it down to Biloxi. That mind was always clicking."

Marion and Holmes were regular diners at the Old French House, usually on weekends, and for special occasions, like birthdays. "Mary always made a grand entrance. We'd love to go down just to see what she might be wearing that night."

Mary was a die-hard New Orleans Saints fan, and since the restaurant was closed on Sundays, if she didn't have time to go to a game and it was televised, a crowd of loyal friends would gather at the Mahoneys or at Marion and Holmes' house and watch the game. "We had our own little Saints group. And Mary was the Saints' biggest fan and supporter—especially after John Mecom [the Saints' owner] started coming into the restaurant, and then Archie Manning. "She was always such fun to be around. Never a dull moment. I miss her. Too bad she had to leave us so soon. She loved life, and she made the most of hers."

Jimmy Balthrope and John Blakeney

Jimmy Balthrope knew Mary and her family all his life, and remembers Mary when she was in her twenties delivering groceries in a wheelbarrow to shrimp boats docked at the wharves behind her father's grocery at Main and Bayview. Later, when he became old enough to drink, he remembers the good times and fun at her bar in the Tivoli Hotel.

"Mary became an instant personality. If something wasn't very interesting, she'd make it interesting. She had personality and style and a great love of the arts. Mary's lounge drew every strata of society."

Balthrope's friend, John Blakeney, also remembers the Tivoli Lounge. "It was the place to go and be seen before and after carnival balls, during the holiday season, and on any special occasion."

Of course, they followed her and patronized the Old French House when Mary opened in 1964. Balthrope lived right next door on Water Street in what is called the Old Spanish House, and he watched the renovation work progress and the restaurant take shape. Balthrope remembers opening night, and he thinks he ate daube (beef) and spa-

ghetti. Blakeney remembers how nervous and frightened Mary seemed to be. "She soon got over her opening night jitters when people began telling her how wonderful the food was and how much they loved what she had done to the old house. "After she hit her stride, she told me, 'John, the secret to the whole thing is to make sure your customers have a really good drink before the meal and good dessert afterwards, and they'll forget the middle part.'" Balthrope said he'll always remember, "Borden's [dairy] made ice cream especially for her—rum raisin. I wish I could get some now."

Blakeney said Mary made it a point to remember the birthday of all her local clients. "She'd send after-dinner drinks to the table and maybe a little cake or something. She never forgot. And she'd never let you buy. The treat was on her."

Both Balthrope and Blakeney said they had close, military friends from Boston and Chicago. "And when they got to town, the first place they wanted to go was Mary's. Everybody just loved her," Balthrope said. "By then, she had become a Coast institution."

Mary gave Balthrope a painting he had admired sometime before she closed her first lounge. The accompanying card said:

> "Love that is horded moulds at last
> Until we know some day
> The only thing we ever have
> Is what we give away."

Balthrope said he had lunch on the porch of the restaurant with Mary and Bob a few weeks before Mary died. "She grabbed my hand over the table and she told me, 'This will probably be the last time we'll see each other.' And it was."

Victor and Gail Mavar

Victor and Gail Mavar were Mary and Bob's next-door neighbors on East Beach. "She brought us over to look at the old house before she started the renovations for her restaurant," Victor said. "A lot I knew. I advised her to buy some land on the beach and open up a brand new place."

Victor said Mary's success came about because she could moti-

vate and organize people. "Everybody who ever had a conversation with Mary wanted her to run for public office. She had an outstanding ability to motivate people and to find people to fill in for the talent she didn't have. She got her brother, Andrew, and got him interested in the venture, and then she found Joe Famiglio. She knew they would both give her 110 percent, and they did."

"We were the best of neighbors," said Gail. "We didn't get in their hair, and they didn't get in our hair. But they knew we were there when they needed us, and they were there for us." Gail remembers trading recipes with Mary and tasting food. "She'd cook something and want me to try it. And I'd do the same. Our kids were much younger than theirs, but Bobby used to come over all the time, and play with them. "I remember Fourth of July parties on the lawn at her house—that was strictly an adult party. And they would go on 'til all hours. But at Easter, she'd hide Easter eggs on the lawn, and let the kids look for them. Mary had baskets for all my children. She was so generous," said Gail.

Gail remembers one time when Mary called her best friend, Jan Schwarz, in from Washington, D.C., to help turn the attic into a bedroom for Eileen. "Mary was so excited about finally getting the project started. She was throwing magazines and things out the open window instead of carting things downstairs. It looked like it was snowing. She tackled everything with such a love for life. You just enjoyed being around her," said Gail.

Over the years, the Mavars' daughter, Elizabeth, got to be best friends with Bobby and Sandy's daughter, Stacy. "They went all through school together. Elizabeth even rode with Bob when he was grand marshall of the St. Patrick's Day parade," Gail said.

Gail thinks the last time she visited Mary was in the apartment upstairs after surgery. "She was sitting there putting pictures in albums, like she wanted to get things organized. She always wanted to make things easier for her family."

Eileen Mahoney

Eileen Mahoney was not the least bit upset by all the preparations underway to open the Old French House Restaurant in the spring of 1964. She was only eight years old and into doing all the things that girls her age were doing. Mary and Bob had already operated the bar at the Tivoli Hotel when Eileen was born, and it wasn't unusual or unsettling for her not to have her parents around, especially at night. "You know how kids these days spend a weekend night at a friend's house? Well, I spent a lot of week nights with Jerry and Annette O'Keefe, who were raising thirteen children. And later, in my teen years, my brother, Bobby, had to take me a lot of places with him. I went bowling with him when he was dating," Eileen recalls.

Daughter Eileen Mahoney took college courses, but says she always knew she would end up helping to run the Old French House Restaurant.

Probably the first hint that the restaurant was attracting national attention came one night when Mary called Eileen from the restaurant. "She told me Jon Provost [who played Timmie on Lassie] was there eating, and he wanted to talk to me. I had a big crush on him, and when he got on the phone, I was speechless. But I managed to spurt something out, and, of course, I couldn't wait to tell my friends." Another time, when Eileen was in her early teens, David Frost came in with Karen Graham, an international model. "Mom called me at home, and told me to get all dressed up and come down to meet them. Well, I had just gone shopping at U Boutique in New Orleans, and I got this new outfit that was set off by shoes that were about eight inches high with the cut-out heels, and when Karen saw me, she said, 'Honey, you're gonna break your neck in those shoes.' I was just crushed."

Of course, Mary saw to it that Eileen started out at kindergarten at Holy Angels run by St. Michael's Church. She went to elementary school at Nativity BVM, then graduated from Sacred Heart All Girls Academy. "Growing up, I was kind of shy," Eileen admits. "I didn't talk a lot. Everybody did the talking for me, and saw that I got everything I needed."

Eileen started driving the family car when she was around thirteen or fourteen years old. "In the days before designated drivers, I was already the designated driver," she laughs. "Mom and Dad loved to spend Sunday afternoons at the Trophy Lounge in the Broadwater Hotel. I'd drive them there, swim in the pool a couple of hours, then drive them home." Eileen got her own car when she was fifteen. "It was a Chevy Monte Carlo—brand new. I'll never forget it."

By that time, the restaurant was running as smoothly as could be expected for any restaurant. The family settled into a routine of sorts, and life was "near normal" in the family home on East Beach. "Mom always cooked on Sunday, liked she promised Grandpaw she would. We would have the Pennsylvania Irishman's diet—meat, potatoes, and corn—every Sunday. And she always burned the bread—that was a tradition."

Eileen accompanied Mary and friend, June Bru, to Europe in 1971 when she was fifteen. "It was one of those wild trips—twenty-one countries in fourteen days. It was wonderful. The airline lost my

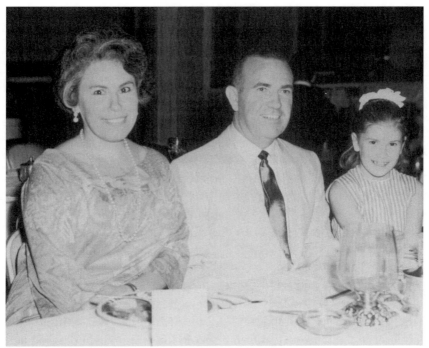

The Blue Room at the Roosevelt Hotel was one of the favorite places where the Mahoneys often dined and took in a live performance. On this visit, Mary and Bob brought daughter, Eileen.

luggage, so I had to buy all new clothes. And you know how my Mom loved to shop." Eileen said her Mom was "pretty disgusted" with Paris. "Nobody paid her much attention in the stores, so she bought all this material. She was always going to have someone make a dress or something when she got back home."

Mary introduced Eileen to the theatre. "I remember going to Mobile and seeing Ginger Rogers in "Hello Dolly." Then another time, seeing Kathy Rigby in "Peter Pan."

After graduating high school, Eileen attended Perkinston Junior College in nearby Wiggins from 1974 to 1976. She lived at Harrison Hall, where her Mom had lived when she was at Perk. Gradually, Eileen came out of her shell and developed her own personality. She was voted a campus favorite in 1976. "I took general studies—no specific major in mind. I always knew I would end up back at the

restaurant," she joked.

Eileen was home from college one weekend and was shopping at Edgewater Mall when Mary had her paged. She had to come home right away. The photographer for the newspaper was there. Eileen would be Queen of the Gulf Coast Carnival Association that February. "That's how Mom did things. I was in blue jeans. I rushed right home to have my picture taken. The rest is a blur."

The next biggest event was Eileen's wedding to Danny Pitalo in October 1980. "Mom sent out 750 invitations, and invited everybody she saw and then some. The reception was held at the restaurant, and there were three bands playing continuously. There were people everywhere—in the restaurant, in the courtyard, in the carriage house. It was a party to end all parties, and Mom was in her glory."

Eileen's first born, Nicole, arrived March 12, 1982, sharing a birthday with Bobby and Sandy's daughter, Stacy. Eileen said Nicole remembers her "Maw Maw" used to paint her fingernails for her. "And, Nicole called her, 'Grandmaw Boobie.' Mom had her sitting on the counter at the bar one time, and Nicole looked down and asked her, 'Maw Maw, why are your boobies so big?' Well, it was the first time I ever remember my mother being speechless."

Eileen's second child, Josh, was born December 23, 1984, about a month after Mary had her first surgery. Mary feared she would not live to see Josh born, but in a letter she wrote to the family while awaiting surgery at Ochsner Hospital, Mary predicted Eileen would have a boy. Mary lived to spend a year of her life with Josh.

Eileen thinks of her mom often, surrounded by the many pictures and other mementos that adorn the restaurant. She works there now as hostess and bartender and helps out wherever she can. Her father, Bob, has become the doting grandfather. "He takes Josh to school, and picks him up in the afternoon. He spends more time with the grandkids than he did with us. And they all love him."

Eileen said she particularly thinks of her mother when she goes to special events at the Saengar Theatre downtown. "Not long ago, I went to see the New York City Opera there, and I kind of looked up at the ceiling and smiled. I thought Mom was looking down and smiling, too."

Gladys Daniels

Gladys Daniels, who grew up near Biloxi's Point Cadet, was working as a cook at the Admiral Benbow Hotel on the beach, when a friend who was working at Mary's Old French House Restaurant told her about a job opening there. Gladys wanted to work closer to her home, and she went to see Mary about the job. That was in 1973, and Mary hired her on the spot.

After giving her boss a week's notice, Gladys started as prep cook to then-chef Marshall Scott. "Mary was a beautiful person. She knew how to treat people. Not everybody has that know-how. She thought of her employees as her extended family."

Gladys was always part of the entourage Mary took to Washington, D.C., each spring beginning in 1979. Mary would feed the entire Mississippi Delegation, an event sponsored annually by the Mississippi Department of Agriculture and Commerce. Before the initial trip, disaster struck. "We had prepared everything in advance, even the seafood gumbo," Gladys recalled. "And Mary was in the kitchen checking everything out for packing on the plane, and the gumbo we prepared on Saturday had gone sour on Sunday. She called all around town looking for me. She was in a panic. When she finally got hold of me, I told her, 'Don't worry, Mary. I'll come in a little early before we leave, and get everything together, and we'll prepare it up there.' And we did."

Mary and Gladys were wide-eyed when they got to the kitchen of the Raburn Office Building in Washington. On tape, Mary said there was everything any chef could possibly need in the kitchen. Mary admitted she got a little restless when the chef showed a lot of attention to Gladys. He later told her he sure liked the way Gladys moved. Mary says she told him, "Well, don't get no ideas, because she's coming back with me."

Gladys said Mary's generosity was legendary. "One time, I was having trouble with the IRS, and I told them I could only pay half of what I owed them, and the other half on time. Well, they wouldn't accept that, so they came to my job looking for me. When I came in to work, Mary said the IRS had been here, and she handed me a

check to pay them off. She said she'd take it out of my pay little by little, as much as I could afford."

Mary was always enticing Gladys and the other restaurant employees to stop by her Mexican Market in the courtyard to see what she had purchased on her latest shopping trips into Mexico. "One day, I saw this beautiful pair of pearls. I told her I liked them, and to put them aside for me, and I'd pay a little at a time," Gladys said. "Well, one night she came behind the serving line in the kitchen. Mary never did that. I wondered what I might have done wrong. Well, Mary came behind me, and slipped the pearls in the pocket of my dress behind my apron. She said that was just a little way of showing how much she appreciated me.

"Another time, when we had a particularly large party, I was running around, helping the chef and serving, too. Later on that night, Mary came up behind me and slipped a $100 bill in my pocket. She said that was a little bonus for helping out."

Gladys said Mary let her prepare and take out all kinds of food from the restaurant when Gladys' daughter, Gina, got married in 1984. Mary and her friend, June Bru, came to the reception at Gladys' house. "I kept asking her, Mary, how much do I owe you for the food, and she would never answer. She said it was her treat. "And that's how everyone feels at Mary's. We're all one, big, happy family. Everybody gets along with everybody."

Gladys, who has raised seven children, still cooks at Mary's, and has watched Chef Georgo move up from dishwasher to head chef. "I knew his father, Niko," Gladys said. "He was a good man. And both of them have worked hard all their lives."

Gladys can be found in the Old French House kitchen on Mondays, Tuesdays, Wednesdays, and Fridays. "I'll probably cook until I drop," she jokes.

Roland Weeks

Roland Weeks, president of Gulf Publishing Company which prints the Biloxi-Gulfport *Sun Herald*, remembers Mary with great love and affection.

He came to take over the newspaper when the State Record Company from South Carolina purchased it from the Wilkes family. Weeks came to the restaurant and asked Mary to host a party so the new owners could meet the political and business leaders of Biloxi.

"The night of the party, the Coast had torrential rains, and the party was scheduled to be outside in the courtyard. 'Don't worry,' Mary told me. 'It never rains on my parade.' And it didn't rain that night."

"We became close friends after that night and remained close friends. There was a bond that was very strong and very special between Mary and me." Weeks would later ask Mary to be godmother to his daughter, Alex.

Weeks said Mary might not have had book smarts, but she was a sly business woman. "I personally consider her a genius. With the right connections, she could have been the Chief Administrative Officer of a Fortune 500 company. There was no luck in what she accomplished. She knew how to make things work, and she knew and cared for this community and its people."

To this day, Weeks, an avid flyer of vintage airplanes, displays in his office on DuBuys Road, a model airplane Mary found for him on one of her shopping trips to the French Quarter. It is enclosed in a glass case. "I have lots more in storage," Weeks laughs. "Wherever Mary would go, she'd always bring me back a model plane, because she knew I love to fly and I love old planes."

Weeks gave a moving tribute to Mary less than a month after she had died, when the Biloxi Chamber of Commerce celebrated its 60th anniversary, and dedicated its membership drive in Mary's honor.

"Mary Mahoney was my friend. That doesn't make me unusual, because she was the original 'Friend of the World.' That's one of the things that made Mary unique and made those she met love her. Of course, there was some salesmanship in that bubbling personality. That's what helped make the Old French House Restaurant successful and brought it to national acclaim. What can you say about a woman who parlayed a $13,000 loan into a business worth millions of dollars in twenty years? You can say she received the Small Business Person Award of the Year for Mississippi, and that her restaurant has been featured in over 400 magazines and newspapers, and

that Mary herself was widely recognized as a tremendous asset to the tourist industry on the Coast. But after you have said all that, you have to say that none of it could have happened had it not been for Mary's love of people and her remarkable ability to win your heart at the same time she was enslaving your stomach. If her kitchen pleased your palate, Mary's incomparable joie de vivre lifted your spirits and reminded you that it is a great thing just to be alive.

"A few nights after Camille hit this Coast, I was in Biloxi. I ventured down toward Mary's to see if there was anything left of the Old French House. I climbed over some debris and saw a light shining from a lantern on the bar. Mary and a few friends were there sharing experiences, but of greater importance, planning for the future. I had been depressed by the death and destruction around us. Mary's optimism and cheerful bravery in the face of adversity were the inspiration that enabled me and many others to go back to our jobs and make plans for a bright future. She touched my life that night and she touched it deeply again last September when Mary Mahoney Day was celebrated in the restaurant courtyard. I still remember her brave farewell to us. 'I am in debt to all you beautiful people,' she said. 'God loves you. I love you.'

"I guess that's what they call 'grace under pressure.' It was a shining example to all of us. I can't think of Mary as just an absent friend. For me, her spirit lives. It lives in the hearts and memories of so many. How could we ever forget her?"

Epilogue

*M*ary Mahoney's Old French House has been a part of the Biloxi business community for over thirty years, and Mary instilled in her family a strong sense of commitment to the people who made the restaurant successful. As their business is family owned and operated, the Mahoneys have a personal involvement with customers, employees, and the community.

The family has a vital interest in helping those it employs. Many young people got their start in the working world as bus people, waiters, and waitresses at Mary Mahoney's. Bus people are trained to become waiters and waitresses in order to increase their salaries if they continue in the family's employ. And several bus boys who are now waiters are working their way through college, and their schedules are "flexible" to allow them to pursue their studies.

Others have made waiting tables at Mary's a career. Some have been with the restaurant since if first opened, and their children and grandchildren worked at the restaurant at one time or another. Waiter Ruben Anderson came to Mary Mahoney's in May 1964, the month she opened, and he's still there. He was among the waiters Mary took with her when she hosted the Congressional dinners in Washington. Anderson said he has enjoyed serving the famous and not-so-famous customers who have come to the restaurant. Among those he's waited on are Paul Newman and Bob Barker. "But Mary treated everybody as special," Anderson said. "And that's what she told us to do." Over the years, Anderson made a good living at the restaurant, providing for his wife and nine children. "We had a good relationship. She was nice to work with. Work *with*," he repeated, "because you never felt like you worked for her, you worked with her."

There never were patrons or clients eating at Mary Mahoney's Old French House. There were only friends. New friends and old friends. A meal was an introduction to Mary, and a spirited conversation about your life and her life. Of course, she wanted to know if the food was good; but more than that, she wanted to know about you.

Waiter Clarence Lashley started part-time at Mary Mahoney's in 1975, and he's still on the premises. "You couldn't find a better boss," Lashley said of Mary. "She understood all her employees, and she tried to do what she could to make them happy." Lashley was one of the waiters who served as pallbearer at Mary's funeral.

Vivian Hersh and her late husband, Sol, ran a clothing and mili-

tary store for twenty years in downtown Biloxi. They frequented Mary's lounge at the Tivoli, and got to be good friends with Mary and Bob over the years. When the Hershes closed their store and became bored with retirement, Mary talked Vivian into coming to work for her as a hostess. That was in 1973. Sol later went to work at the restaurant, too. "We just wanted something to do," said Vivian. "I helped to host primarily, but I'd do anything that needed to be done. Sol would cashier at night and bus tables if he was asked to."

"Mary was a very intelligent person," said Hersh. "She was very knowledgeable on a number of subjects. She knew what she was talking about. She also knew her food—the taste and the flavor it had to have, and she was always open to suggestions. Sometimes I'd get so upset when things went wrong. But Mary would never cry over it. She'd go on to something else."

The Mahoney family participates in many civic endeavors. They hold memberships in the Elks Club, Rotary Club, Gulf Coast Chamber, Biloxi Bay Chamber, Gulf Coast Carnival Association, Hibernia Society, and Sunkist and Broadwater Country Clubs. Bob is a past member of the Biloxi Development Commission and was instrumental in the revitalization of downtown Biloxi.

Bobby is a past president of the Mississippi Gulf Coast Restaurant and Beverage Association, and served as a commissioner on the Mississippi Coast Coliseum. He was a primary force in the drive to legalize gambling in Mississippi.

Both Bob and Bobby have been dukes in the Gulf Coast Carnival Association's annual ball. Eileen is a past Queen of Mardi Gras, as is Stacy, Bobby and Sandy's daughter. And their daughter Caty, was Queen in 1978.

Mary Mahoney was the first woman president of the Biloxi Chamber of Commerce (1984-1985). She helped establish the first Hibernia Society in Biloxi, and the first St. Patrick's Day parade originated in the restaurant's courtyard. She was a savvy businesswoman, an active civic presence, and a loyal friend.

Mary Mahoney touched the lives of many. She inspired hope and renewal of spirit. Her laughter, energy, and generosity seemed without bounds. Mary knew no stranger and welcomed with open arms those who entered her world. Her love of life infected countless indi-

viduals. The brightly clad lady in butterfly glasses stands as a giant among men and women in the memory of those of us who knew and loved her.

Mary wearing a pair of her famous butterfly glasses.

Recipes

For popular dishes served at
MARY MAHONEY'S
Old French House Restaurant

CRAB MEAT AU GRATIN

5 tablespoons butter	1 teaspoon salt
3 tablespoons flour	¼ teaspoon black pepper
1 cup milk	Dash Tabasco
1 cup chicken bouillon	1 tablespoon Worcestershire sauce
1 egg, well beaten	1 pound lump white crab meat
2 tablespoons sherry	1 cup grated Cheddar cheese

Make a white sauce of butter, flour, milk, bouillon, and egg. Remove from heat; add sherry, salt, pepper, Tabasco, and Worcestershire sauce. Add crab meat to white sauce and put in 1½-quart casserole or 6 individual ramekins. Sprinkle with cheese and bake at 350° for 20 minutes, or until bubbly brown.

SHRIMP ITALIENE SALAD DRESSING

1 pound small peeled shrimp	2 teaspoons Worcestershire sauce
½ cup vegetable oil	½ teaspoon garlic powder
½ cup distilled vinegar	½ cup celery
1 small can tomato juice	⅓ cup green onions
1 teaspoon Italian seasoning	2 hard boiled eggs

Thaw and rinse shrimp. Add to salted boiling water and boil 5 minutes. Combine oil, vinegar, tomato juice, Italian seasoning, Worcestershire sauce, and garlic powder. Chop celery, green onions, and hard boiled eggs finely and add to dressing mixture. Stir and add shrimp.

Serve over 6-8 individual mixed salads. Salt and pepper to taste.

LOBSTER GEORGO

2 whole cooked lobsters
½ cup small, peeled,
 cooked shrimp
⅓ cup diced mushrooms
1 cup grated Cheddar cheese

5 teaspoons brandy
2 cups cream sauce
Parmesan cheese
Dash paprika

Split both lobsters into halves. Peel off tails. Chop tails into small pieces, add shrimp, mushrooms, Cheddar cheese, brandy, and cream sauce.

Stuff lobster with above. Top with Parmesan cheese and dash of paprika. Bake at 350° in a preheated oven for approximately 15 minutes. Serves 4.

SEAFOOD GUMBO

6 tablespoons flour
5 tablespoons bacon drippings
2 onions, chopped fine
1½ cups finely chopped celery
1 garlic pod, chopped
1 large can tomatoes
1 can tomato sauce
5-6 cups water

3 teaspoons salt
1 teaspoon pepper
2 pounds shrimp (fresh or frozen)
2 pounds crab meat
 (fresh or frozen)
1 package cut okra (frozen)
3 tablespoons Worcestershire sauce
1 pint oysters (optional)

Brown flour in bacon drippings to make roux. Add onions, celery, and garlic and brown for 5 minutes. Add tomatoes, tomato sauce, water, salt and pepper, and boil for one hour over medium fire. Add shrimp, crab meat, and okra and cook 20 minutes longer. Add Worcestershire sauce. Stir well and serve over steamed rice.

IRISH COFFEE BALLS

2 cups vanilla wafer crumbs
1 cup chopped pecans
2 tablespoons white Karo syrup
1 tablespoon cocoa

1 tablespoon instant coffee
1 cup powdered sugar
⅓ cup Irish Whiskey

Mix all of the above ingredients. Take about 1 teaspoon of mixture and roll into a ball. Roll in powdered sugar. Makes about 50 balls.

BREAD PUDDING

6 slices day old bread
1 teaspoon cinnamon
½ cup seedless raisins
2 tablespoons butter, melted

4 eggs
2 tablespoons plus ½ cup sugar
2 cups milk
1 teaspoon vanilla extract

Break bread in small pieces in 1½-quart baking dish. Sprinkle cinnamon over bread and add raisins and melted butter. Toast lightly bread mixture in oven about 350°. Then add mixture of eggs, sugar, milk, and vanilla extract, after mixing well. Bake about 30 minutes or until solid. Serves about 8.

RUM SAUCE:

2 cups milk
½ stick butter
½ cup sugar
2 tablespoons flour

1 tablespoon oil
1 tablespoon nutmeg
1 tablespoon vanilla extract
Rum to taste

Place milk, butter, and sugar in saucepan; let come to a boil; thicken with a roux made of flour and oil. Remove from fire, add nutmeg, vanilla, and rum. Serve over pudding.

MARY MAHONEY'S PRALINES

2 cups sugar
1 can Carnation cream
3 tablespoons butter or
 margarine

1 teaspoon vanilla
1½ cups pecan halves or
 chopped pecans

In a heavy saucepan stir together sugar and cream. Bring to a boil over medium heat, stirring constantly. Cook to 234° (soft-ball stage) stirring to prevent candy from sticking. Add butter or margarine and vanilla while continuing to stir candy mixture. Add pecans and beat candy for 2-3 minutes or till candy begins to feel thick. Drop candy from tablespoon onto waxed paper or aluminum foil. Let candy cool before removing from paper.

Index